BIRMINGHAM AIRPORT

THROUGH TIME

Peter C. Brown

AMBERLEY

First published 2017

Amberley Publishing
The Hill, Stroud, Gloucestershire, GL5 4EP
www.amberley-books.com

Copyright © Peter C. Brown, 2017

The right of Peter C. Brown to be identified as the
Author of this work has been asserted in accordance with
the Copyrights, Designs and Patents Act 1988.

ISBN 978 1 4456 6410 1 (print)
ISBN 978 1 4456 6411 8 (ebook)

British Library Cataloguing in Publication Data.
A catalogue record for this book is available from the
British Library.

Origination by Amberley Publishing.
Printed in Great Britain.

Birmingham Airport (IATA – International Air Transport Association – code: BHX, ICAO – International Civil Aviation Organisation – code: EGBB) has two passenger terminals, and currently employs approximately 7,000 staff, around 700 of whom are employed by the airport. Over fifty airlines fly to approximately 100 destinations worldwide, and in 2016 recorded 11.6 million passengers in the long- and short-haul sectors – the busiest year in the airport's seventy-five-year history. Birmingham also has a CAA Public Use Aerodrome Licence (Number P451) that allows flights for the transport of passengers or for flying instruction.

The Early Years

Billesley Aerodrome

Billesley Farm, situated off Yardley Wood Road, King's Heath, was the meeting place for the Midland Aero Club in 1910 (established on 3 September 1909, it was one of the earliest private flying clubs, and it would go on to become one of the oldest flying clubs in England), and was joined by the Birmingham Aero Club in 1911 (until 1914) for model flying and glider practice. A 'club' aeroplane was made available for prospective new members to come and try and, on 30 September, a 'Championship of the Midlands' competition was organised, which offered two gold-centred silver medals; one for the winner of the senior championship, the other for the junior.

The first manned air flight at Billesley aerodrome was in August 1913 when the early aviator Edwin Prosser (who had received his Aviator's Certificate in June) flew his Caudron biplane the twenty-four miles from Billesley to Stratford-on-Avon in eighteen minutes, and achieved an ascent of 5,000 feet on the return journey. The Midland School of Flying commenced operations at Billesley with a 50 hp type Bleriot on 23 July 1915.

In 1919, Birmingham City Council purchased Billesley Farm and its surrounding fields for urban development, and the last known use of Billesley aerodrome was in October 1920 when Alan Cobham's Flying Circus was offering 'joy rides'. By 1931, some 3,500 council houses had been built, and the local community hall is situated on the site of the original farmhouse.

Castle Bromwich

The Midland Aero Club had moved away from Billesley Aerodrome, and by 23 May 1912 had established itself just over eight miles away at the privately owned Castle Bromwich aerodrome (the area is now called Castle Vale), which had been developed from playing fields. Originally used for sewage farming, large culverts had been constructed below the surface to aid drainage, and the surface had been carefully built up and levelled, and laid to grass. The club moved to Elmdon Airport in 1937 and became famous for organising spectacular air pageants, which continued until 1951 when it was considered too dangerous to hold such events so close to an airport with increasing volumes of air traffic.

The inventor Alfred Pericles Maxfield became the first man to fly in the Birmingham area when he successfully flew his home-made aeroplane from the golf course at Castle Bromwich in September 1909 and, in 1911, Bentfield C. Hucks – the first British pilot to achieve a loop-the-loop – was offering passenger flights for two people at a time in his Blériot monoplane.

A hangar was built for the aeroplanes and Castle Bromwich became a stopping place during early air races. In 1914, a crowd of 80,000 people gathered at the aerodrome on 20 June to watch the arrival and departure of the competitors taking part in the Great Air Race from London to Manchester and back. The competitors had to land at the control point and were registered when their feet were on the ground.

The aerodrome was requisitioned in August 1914 by the War Office for use by the Royal Flying Corps (RFC) and flying schools and as well as proper roads being constructed, offices, sheds, and hangars were also established for the shelter and testing of aircraft. Tents were erected as a temporary measure at the edge of the runway along with a marquee used as the Mess for use by the trainee pilots. No. 10 Squadron RFC, which was equipped with Maurice Farman biplanes, was the first training squadron to be based at Castle Bromwich. No. 5 Reserve Aeroplane Squadron (later becoming No. 5 Training Squadron), which was formed at the aerodrome on 11 May 1915, was equipped with MF.7 Longhorn and MF.11 Shorthorn Maurice Farman reconnaissance and light bomber biplanes. Nos 19, 34, 38, 54, 55 and 71 Squadrons RFC, and Nos 115 and 132 Squadrons of the Royal Air Force (RAF) resided at the airfield at various times during and just after the First World War with a large variety of aircraft, which included the Bristol F2, RAF R.E.7, RAF B.E.2c/e, Avro 504, Sopwith Pup and de Havilland DH.9A.

Nos 38 and 90 RFC Home Defence squadrons were stationed at Castle Bromwich for duties in the Midland Counties area and it was also the location for No. 14 Aircraft Acceptance Park (AAP), which was established for the receipt and inspection of aircraft. The AAP system was established in 1917 to augment factory inspections that were unable to keep up with the demand for more aircraft. The parks were situated close to each aircraft production factory group.

Flying was a very dangerous business in those days and there were more than seventy flying accidents at Castle Bromwich during the First World War, with thirty pilots being killed and fifty seriously injured. A number of them are buried in Castle Bromwich graveyard.

After the cessation of hostilities in November 1918, the War Office notified the Drainage Board that it intended to keep the aerodrome – which, with its additional buildings, covered an area of 340 acres – for military use. The Air Ministry, however, wanted to retain civil flying and granted a civil aviation licence to the Midland Aero Club – with the proviso that it would use the northern portion of the aerodrome.

The British Aerial Transport Company started their first London (Hendon) to Birmingham passenger service on 29 September 1919.

From 1920 until 1956 (except during the Second World War), nowhere in the country welcomed more visitors than Castle Bromwich when, for two weeks of every year, it was the venue for the British Industries Fair (the forerunner of the National Exhibition Centre) – the busiest exhibition centre in Britain – and a large complex of buildings had been built between the aerodrome and the railway line to accommodate it.

Seventeen competitors took part in the first King's Cup Race – inaugurated by King George V to encourage the development of the light aircraft industry in Britain – on Friday 8 and Saturday 9 September 1922 from Croydon to Glasgow, for which Castle Bromwich was the recording and refuel stop. A repeat performance took place on 13 July the following year.

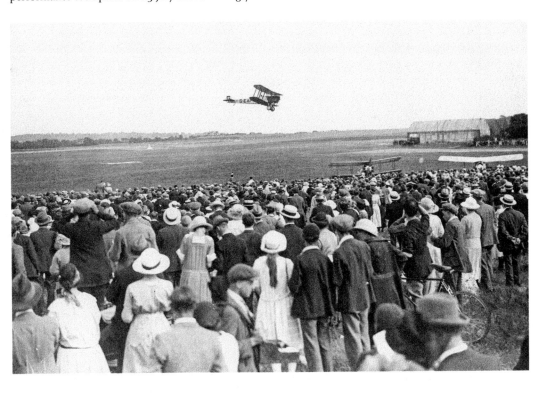

1922
Captain Frank C. Broome in his Avro 545 (G-EAPR) during the first contest of the King's Cup Air Race in September 1922. (Royal Aero Club Trust)

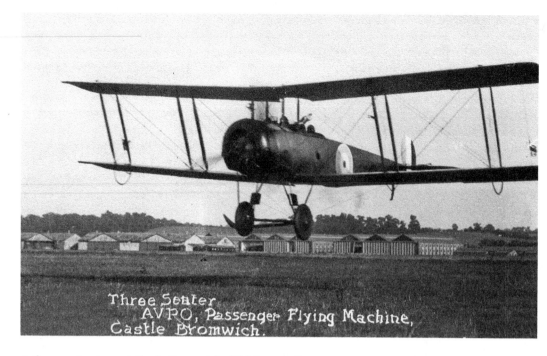

A three-seater Avro at Castle Bromwich. (Old Postcard)

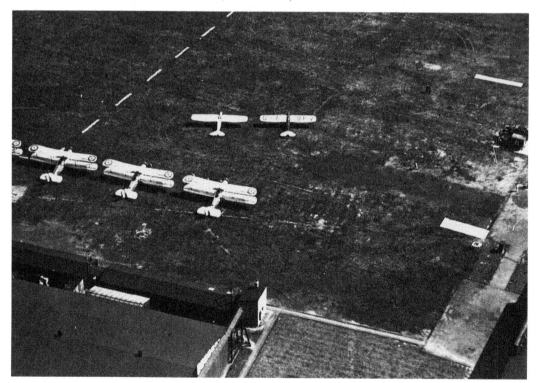

1933
Castle Bromwich aerodrome in the 1930s. (Rod Lightbody)

Despite the aerodrome having a limited use expectancy as industrial factories began to sprout up across Birmingham, thus creating a very unsuitable site for an airport, the Air Ministry purchased the site – 179 acres of land with buildings bounded on the north by Kingsbury Road, on the east by Park Lane and Plant's Brook, on the south by the main drive to Berwood Hall Farm, and on the west by Chester Road and the Board's premises at Tyburn – in 1925 for £60,000.

In the latter half of 1925, the British Government subsidised five Aero clubs; the London, the Lancashire, the Newcastle, the Yorkshire, and the Midland Aero Club, which took delivery of two de Havilland DH.60 Tiger Moths (G-EBLT and G-EBLW) to go with their Austin Whippet (G-EAPF). The club went on to organise the Birmingham Aerial Pageant over the weekend of 16/17 July 1927, in which 100 aircraft took part and attracted over 100,000 visitors.

605 County of Warwick Squadron was formed at Castle Bromwich on 5 October 1926 as part of the newly formed Auxiliary Air Force, and was initially equipped with de Havilland DH.9As. Wapitis in 1930, and Hawker Hinds in 1936. The squadron was relocated to Tangmere in January 1939 as a fighter squadron flying Gloster Gladiators and Hawker Hurricanes.

On 11 May 1933, the Great Western Railway (GWR) Air Services inaugurated a twice-daily return service using a six-seater three-engined Westland Wessex IV (G-AAGW) – supplied with pilots by Imperial Airways – between Cardiff and Plymouth which, on 22 May, was extended to take in Birmingham. A passenger travelling from Birmingham to Plymouth would fly via Cardiff, Teignmouth, and Torquay. However, despite the service being extended to Liverpool, London, and Brighton in the following year, the Air Ministry warned

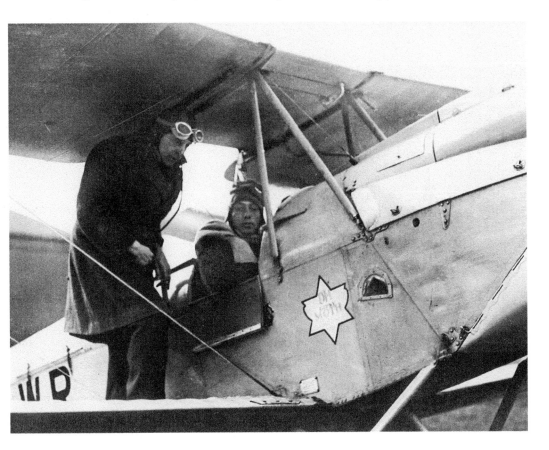

Jacob Weinherth aboard a de Havilland Gipsy Moth (G-AAWR) of Yorkshire Aviation Services. (Rod Lightbody)

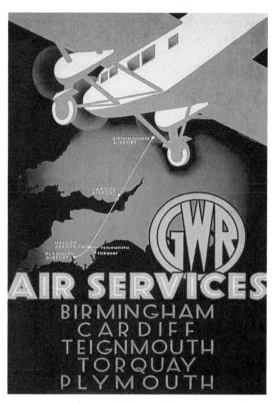

Great Western Railway Air Services
poster 1933. (Author's Collection)

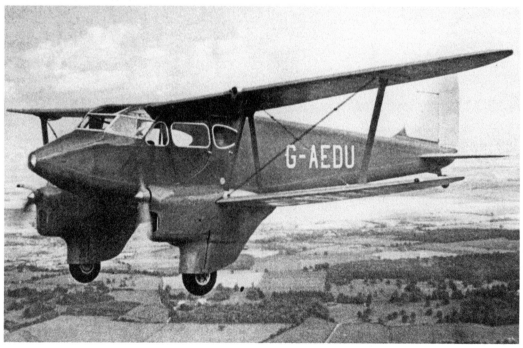

1935
De Havilland DH.90A Dragonfly (G-AEDU) *c.* 1935. (Author's Collection)

that Castle Bromwich could not be used indefinitely as a civil aerodrome because of plans for it as a training and experimental facility.

The 'Great Western' was dropped from the title in 1934 and Railway Air Services Limited, formed by the 'Big Four' rail companies, continued to operate until the outbreak of war in 1939. Following the war, Railway Air Services became part of British European Airways Corporation.

The British government had formalised a plan under the Air Ministry in 1936 to increase capacity within Britain's aircraft industry, and part of the programme was funding an enormous brand-new £4 million aircraft production facility near Castle Bromwich aerodrome, which would employ the skills-base and techniques (such as component jigging) that was used in the manufacture of motor vehicles for aircraft production. Eighteen blocks were constructed on the site; 'A' Block was used for the final assembly of the Lancaster bomber with 'B' Block the receiving bay for sub-assemblies for both the Lancaster and the Spitfire from thirty-two dispersal factories around the Midlands that produced cockpits, wiring looms, and instrument panels. The remaining blocks included maintenance, tool rooms and Pattern shops, a garage, boiler house, hospital (with a mortuary), laboratory, admin offices, and a canteen. The glazed-roof buildings that housed the main facilities were completed in 1939 but because of severe delays in organisation, the first Spitfire Mk IIs didn't begin to leave the production line until June 1940. The buildings would remain part of the industrial landscape for more than fifty years.

The chief production test pilot for the Spitfires produced by the Castle Bromwich Aeroplane Factory (CBAF) at the time was the famous air-racer Alexander Henshaw (1912–2007), who is especially noted for his record breaking Gravesend, Kent – Cape Town, South Africa and return journey in February 1939 in his Percival Mew Gull (G-AEXF).

The airport was officially opened on 8 July 1939 by HRH, the Duke of Kent, but two months later the airport was closed to all civil aircraft due to the outbreak of war. Additional hangars and a squadron headquarters had been built for the RAF in 1937 and it had been further extended in 1939 to become a fighter station and a base for other units. After the Air Ministry requisitioned the airport, the 06/24 runway was laid. In July 1937 the Midland Aero Club was contracted to run No. 14 ERFTS for the training of new pilots of the Volunteer Reserve until 9 September 1939, when it transferred to Elmdon aerodrome.

The Austin Motor Company at nearby Longbridge was heavily involved with the manufacture of single-engine aircraft, including the Fairey Battle, the Hawker Hurricane, and Miles Master. A shadow

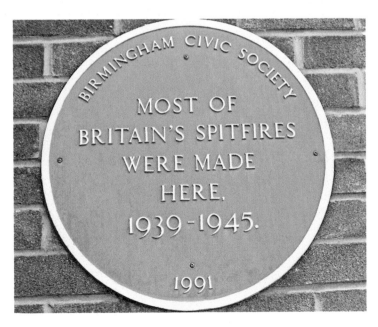

The blue plaque erected by the Birmingham Civic Society in 1991 at what is now the Jaguar plant to commemorate the site where the UK's largest number of Spitfires were built during the Second World War. (Author's Collection)

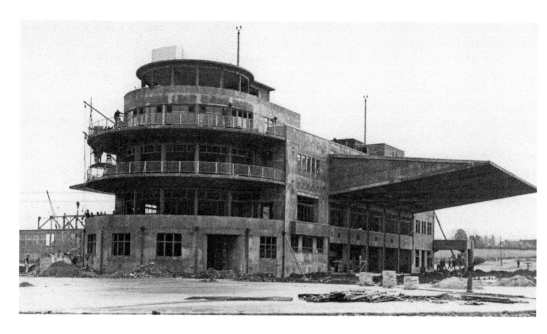

1939
Elmdon Airport terminal under construction in February 1939. (Author's Collection)

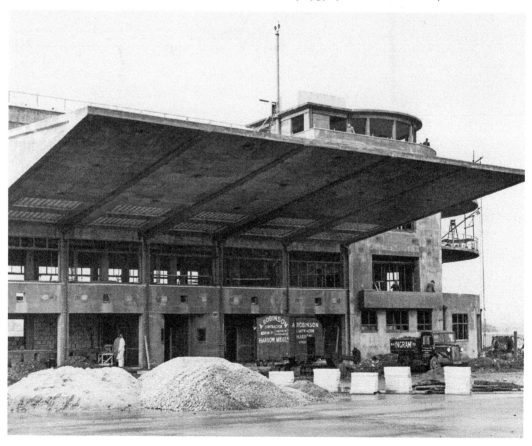

factory was also set up in the village of Cofton Hackett as the final assembly point for Avro Lancaster and Short Stirling bombers but, because the runways at Longbridge were too short for flight testing, the aircraft were towed along Groveley Lane and across the high bridge over the Halesowen to Northfield railway line to Elmdon. Once they were declared airworthy, they were then flown to their operational units. The Avro Lancaster B VII (NX611) *Just Jane* was one of the last wartime bombers to leave the factory.

With Castle Bromwich aerodrome designated as the headquarters of an 'Anti-aircraft Co-operation Unit' – a concrete Battle Headquarters with tunnel access was constructed at the aerodrome *circa* 1940/41, which would have been used to co-ordinate the defences if the Germans had attacked it. Nos 911, 912 and 913 Squadrons under the No. 5 Barrage Balloon Centre at RAF Sutton Coldfield protected the north of the city, the aerodrome and the Spitfire factory (which also had its own Home Guard comprising of the 52nd Battalion Royal Warwickshire Regiment), and five heavy anti-aircraft guns at an army camp that had been set up in the Parkfield Drive/Water Orton Road area.

As part of the German air raid dubbed 'Eagle Day' on 13/14 August 1940, the aircraft factory at Castle Bromwich was bombed, causing significant damage to the buildings, killing seven people and injuring forty-one others. With Fighter Command (12 Group) still recovering after being stretched to its limits during the Battle of Britain (10 July – 31 October 1940), the air raids intensified over the following months as the Luftwaffe tried to knock out industrial targets, which included the Austin works and its shadow factory at Longbridge, and other factories that had been turned over to the manufacture of components for the war effort. On the night of 23 August, a low-level raid took place on the streets and villages surrounding the aircraft production plants – a direct attack on the workers themselves. The most serious raid on Birmingham

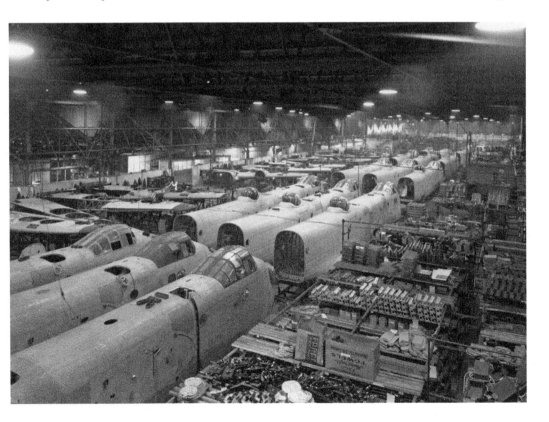

1941
The ninety-foot-long fuselages of Stirling bombers assembled at Longbridge in 1941 from kits produced by Short Brothers. (British Motor Industry Heritage Trust)

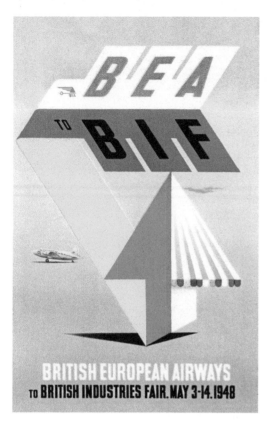

1948
The 1948 BEA Festival of Britain poster for the British Industries Fair held at the showgrounds at Castle Bromwich. (Author's Collection)

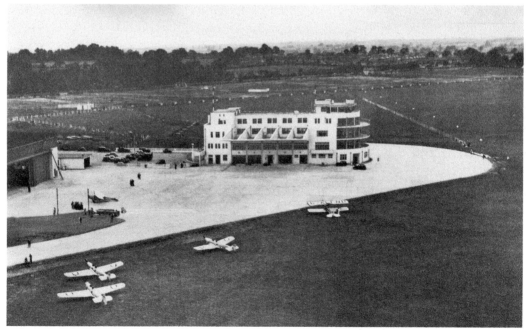

1949
Birmingham Airport in 1949. (Author's Collection)

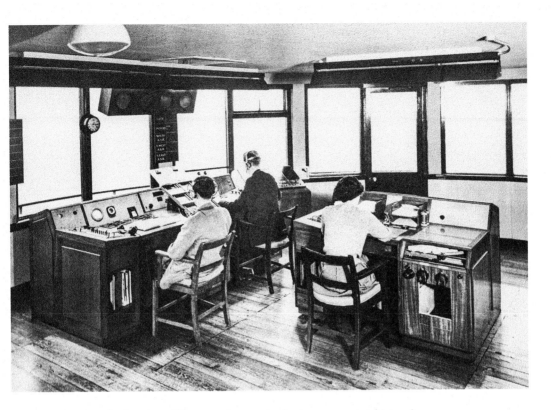

On duty inside the air traffic control tower in the late 1940s. (atchistory)

took place on 19 November when 441 bombers attacked the city itself, dropping around 400 tons of bombs and high explosive parachute mines – killing 450 people and badly injuring 540 others. The very last raid on the city was on 23 April 1943.

After the first Avro Lancaster bomber built at CBAF was flown on 22 October 1943, the rate of production of the bombers steadily increased, and the plant would become the largest and most successful of its type during the Second World War. The factory, which produced all versions of the Spitfire from the Mk II onwards, closed its aircraft production in 1945 and the airfield became a training station. Civilian flights returned – which included the first scheduled helicopter service from London – and the airport was host to the annual 'At Home' air and static displays (although these were mostly RAF, FAA and Army) from 1945 until 1957, which drew enormous crowds, and included a wide variety of aircraft such as Ansons, Canberras, Hastings, Lincolns, Meteors, Shackletons, Vampires and, in the latter years of the show, North American Sabres.

The airport closed on 31 March 1958 and the site was sold in 1960 for social housing development. Very little evidence remains of its existence apart from some streets and housing blocks that have 'aviation' names, a row of ex-RAF houses along Chester Road, and 'Spitfire Island' – the roundabout at the intersection of Chester Road and the A47 Fort Parkway at the entrance to the Castle Vale estate. A 52-foot-tall (16 m) sculpture called 'The Sentinel', designed by Tim Tolkien (great-nephew of the author J. R. R. Tolkien), depicting half-scale aluminium Spitfires with curving steel supporting beams that act as vapour trails, designed to capture the dynamics of the Spitfire in flight, was erected on the roundabout and opened on 14 November 2000.

Elmdon Municipal Aerodrome

The council had decided as far back as 1928 that as Birmingham was an important industrial city, it must have an airport and, after discounting a possible site adjacent the Stratford Road in Shirley, Solihull, Elmdon Municipal Aerodrome was established within an 800-acre area of land north of Coventry Road in the Parish of Bickenhill on the outskirts of Birmingham. It was purchased for £130,613 in 1933 by Birmingham Council and would be developed to meet the needs of residents and businesses in the city and the immediate surrounding area. 215 acres were allocated for development by B. Sunley & Co. Ltd, which included the amalgamation of the fields by the removal of hedges, felling trees, and filling natural ponds. An immense drainage system was installed before construction began on the roads, buildings, and lighting at a further cost of £163,508.

The four-storey terminal building, which was unique among airports in the United Kingdom, was designed by architect Nigel Norman and engineer Sir Graham Dawbarn, who modelled it on the control tower at Berlin Templehof Airport, Germany. It had two canopies that extended 50 feet (15m) out either side from the reinforced structure of the 64-foot-wide (19.5m) building, which served to provide shelter from the weather for passengers and their baggage on their way to boarding the aeroplanes.

The aerodrome began operating commercially on 1 May 1939, with a British Klemm L.25C-1A Swallow (G-ACXE) being the first aircraft to arrive from Castle Bromwich. The first scheduled arrival was de Havilland DH.89A Dragon Rapide (G-ACPP) *Volunteer* of Great Western & Southern Airlines, operating from Liverpool via Ringway (Manchester) to Bristol, Southampton, Ryde and Shoreham.

Air services to Croydon (with connections to the Continent), Glasgow, Liverpool, Ryde, Shoreham, Manchester, and Southampton were operating by the end of the month. No. 44 RAF Elementary and Reserve Flying Training School (operated by Airwork) opened at Elmdon with Hawker Hind and Audax light bombers, and Miles M.14 Magisters. The largest operator at the time was Western Airways, who were allocated a licence by the new Air Licensing Authority to operate a thrice-daily service from Weston-super-Mare to Ringway (Manchester) via Elmdon, winning the bid against their rival Great Western & Southern Airlines. The service started on 17 June.

The Duchess of Kent, Prime Minister Neville Chamberlain, Air Minister Sir Kingsley Wood, and other dignitaries attended the opening ceremony on 8 July (thus replacing Castle Bromwich as the city's main airport). Despite the poor weather, an air show took place which included an RAF contingent of eight Spitfires, Whitley, Hampden, and Blenheim bombers, the civilian aircraft prototype DH.95 Flamingo (G-AFUE), and the Royal Flight Airspeed Envoy (G-AEXX).

The Air Navigation (Restriction in Time of War) Order was implemented on 29 August 1939 by the British Government, which ordered the military takeover of most civilian airfields in the United Kingdom, the cessation of all private flying without individual flight permits, and other emergency measures. Subsequently, no further scheduled services operated to or from Elmdon during the build-up to the Second World War. The aerodrome was requisitioned by the Air Ministry on 16 September for use by the Royal Air Force and the Royal Navy as RAF Elmdon, and the 14th Elementary Flying School took up residence with de Havilland DH.82 Tiger Moths for training RAF and Fleet Air Arm pilots.

Two intersecting hard surface runways – 06/24 at 2,469 feet (752m) and 15/33 at 4,170 feet (1.27km) – were built by the Air Ministry to replace the original grass landing strip and the aerodrome was also provided with a number of arched 'Blister' and rolled steel 'Bellman'-type aircraft hangars, as well as utilising the Bryant-built civilian hangars and a 'Type 24' concrete pillbox just beyond the airport perimeter alongside the A45.

Post War

The aerodrome remained under military control until 1946, when it was handed over to the Ministry of Civil Aviation, and although civil flying resumed on 8 July, and the aerodrome was the venue for Air Fairs and the annual Air Races, it wasn't until the late 1940s that scheduled services commenced again.

In 1946, First Lieutenant Maureen Dunlop – who was one of a pioneering group of women pilots who flew the latest fighter and bomber aircraft for the Air Transport Auxiliary (ATA) during the Second World War – set up at Elmdon with her Test Flight comprising of a Vickers Wellington III (BK563), Armstrong Whitworth A.W. 41 Albemarle (V2046), Bristol B.1 Buckingham (KV479) and, later, an Avro Lancaster Mk I (PB752) and Percival Proctor (G-AHBA). The enterprise ended in 1949.

Charter (passenger and freight) companies such as Patrick Aviation Ltd, Cambrian Air Services, International Airways and Air Enterprises operated services to the Isle of Man, Jersey, Cardiff, London (Hendon), and Croydon, Blackpool, Weston-super-Mare, the Isle of Wight, and the Channel Islands mostly with de Havilland DH.89 Dragon Rapides. Wings and Wheels – aka Hargreaves Airways – and The Yellow Air Taxi Company offered pleasure flying and pilot training, as well as charter flights.

European Airways (BEA) operated the first Continental service (Manchester to Paris via Elmdon) with a Douglas Dakota (G-AHCU) on 8 April 1949, but the venture proved unsuccessful and plans for other Continental routes were shelved. In contrast, Aer Lingus introduced a service to Dublin with Douglas Dakota DC-3 *St Declan* (EI-ACL) operating the first flight on 2 May, and the service proved to be a great success.

A successful two-way Pye VHF radio-telephone demonstration was carried out at the National Air Races (which included the King's Cup and seven new events), held over the Bank Holiday weekend of 29 July – 1 August 1949 between the communications control officer at the airport and cars that were fitted with the system placed at key points over the 20-mile course, linked via landline to the public address system, the emergency ground crews, and the on-site BBC commentator. Sodium flares were placed by each of the Dunlop Pylons and were a great help to the high-speed pilots, of whom Peter Lawrence in his Firebrand TF5A (EK-621) was the eventual winner with an average speed of 302 mph.

1950s

Despite the poor support for the Paris service, new services using Douglas Dakotas were gradually introduced in the early 1950s to Belfast, Jersey, Glasgow (via Manchester), Edinburgh (via Glasgow), and Northolt, but again they were poorly supported and resulted in cancellations or cutting out additional stops. BEA, which effectively controlled all domestic scheduled services and the independent airline operators at Elmdon at the time, ordered sixteen Vickers V.701 Viscount Turboprops for its fleet in August 1950 and, during the interim period until they were delivered, operated Airspeed Ambassador 'Elizabethans' to replace the Dakotas on their domestic services and the Manchester to Paris (via Birmingham) service, which started on 13 March 1952. When the Viscounts were introduced by BEA in 1954 (the first being G-ALWE *RMA Discovery*), the flying time on the Paris route was cut from 195 minutes to 150 minutes – including the 25-minute lay-over at Elmdon.

In 1951, Birmingham Corporation built a service road from Hob Moor Road to the BEA-built experimental 'Rotor station' – a 'Heli-pad' and associated buildings constructed at Haybarnes Farm, close to the River Cole off the A45 (Coventry Road, 3.5 miles from the city centre), from where it operated three Sikorsky S-51 and two Bell 47B helicopters purchased from the USA for a thrice-daily Birmingham to London (Northolt) service. However, the passenger service faded within a year and gave way to a daily freight service between Elmdon Airport, Birmingham, and London Airport. British-built Bristol 171 helicopters were introduced to the service in 1954 and two years later operated passenger feeder services for BEA's Elmdon to Paris fixed-wing service from Elmdon airport.

Air Kruise launched a weekly service in 1953 from Manston (Kent) to Elmdon using de Havilland Herons and Rapides, but Eagle Aviation, which had been using Dakotas on their steadily growing passenger charter operations, were denied the licences to operate flights with Vickers Viscounts from Elmdon to European destinations, and so settled for a licence for all-cargo flights to Germany in 1954.

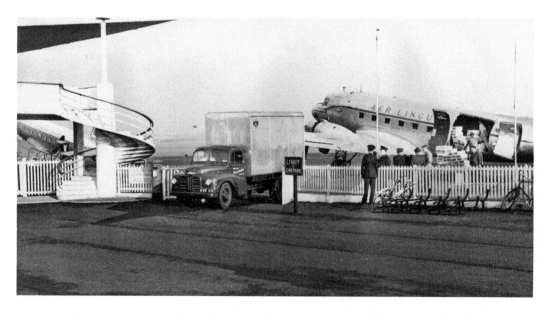

1951
Co-operative Austin lorry delivering cargo to an Aer Lingus DC-3 at Elmdon Airport *c.* 1951. (Co-Op History Group)

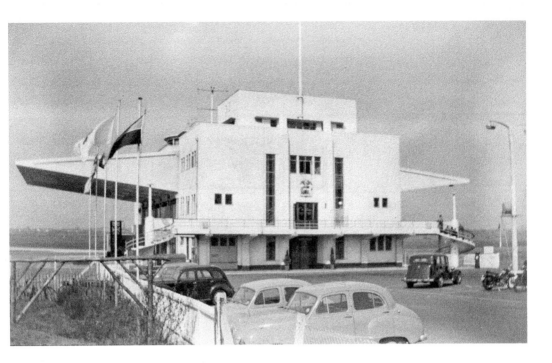

1956
Elmdon Airport in 1956. (Dick Warren)

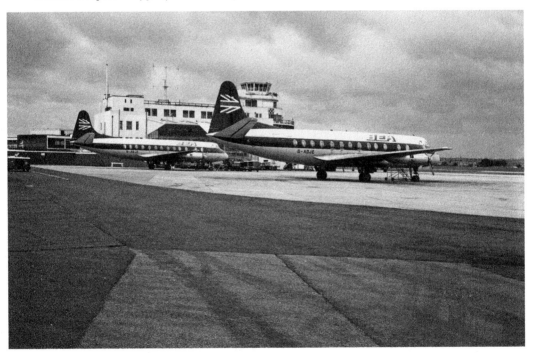

1958
BEA Vickers Viscount V.802 Turboprop G-AOJE with G-ADJF *RMA Sir George Somers* at Elmdon *c.* 1958. (Alan Pratt)

Derby Aviation (later Derby Airways and then becoming British Midland Airways) launched a Derby–Wolverhampton–Jersey service on 18 July 1953, initially using a de Havilland Dragon Rapide (G-AEAL), which called in at Elmdon airport for customs clearance. The company purchased Douglas Dakota (G-ANTD) to expand its services that included a Derby–Birmingham–Ostend service in 1955.

Airwork Ltd, which became the first carrier to be awarded a UK to Singapore trooping flight contract by the War Office in the early 1950s, started the first cargo flights from Elmdon to New York on 6 August 1955 with a Douglas Dakota DC-4, leased from American carriers while they awaited their order for two Douglas DC-6As. Airwork went on to acquire control of Transair (a fellow independent airline) in 1957 and two years later took over Air Charter – Freddie Laker's first airline venture. On 19 May 1960 Airwork changed its name to British United Airways (BUA).

Silver City Airways, a private British independent airline formed in 1946, launched its first air ferry services between Scotland and Ireland in 1955 and its first such service from the Midlands, which linked Stranraer with Belfast and Birmingham with Le Touquet. They also operated a freight and vehicle ferry service from Blackbushe–Elmdon–Formby–Belfast, until 31 December 1961.

The length of the runway at Elmdon became an issue for Air Paris when it began a scheduled service using Dakota DC-4s to Elmdon in 1953 – the result being that the aircraft had to be flown 15,000 lbs below its normal loaded weight. BEA's new twice-weekly night service to Zurich in 1955 and a Vickers Viscount service to Dusseldorf in the following year were also affected because the runway could not support its fully-laden aircraft operations. Eventually, in 1958, Continental services were suspended while the runway was extended by 800 feet.

Soviet Premier Nikita Khrushchev, who succeeded Josef Stalin as leader of the Soviet Union, arrived with Minister of Defence Marshal Nikolai Bulganin at Elmdon by a scheduled BEA V.701C Viscount (G-ANHC) flight on 23 April 1956 to attend the British Industries Fair held in Birmingham.

Don Everall Aviation (a division of the Wolverhampton-based coach operator) started an ill-fated chartered service to the Isle of Wight in 1955 and, on the evening of 7 October 1956, their de Havilland DH.89A Dragon Rapide (G-AGLR) was on a return flight from Le Bourget, France, to Elmdon when it crashed and burned out at Four Oaks Crossroads near Berkswell – just two minutes' flying time short of the airport. The pilot and his nine passengers escaped unhurt but both he and the company were summoned and prosecuted for several breaches of regulations – the most directly relevant to the crash being the failure to check that the aircraft had sufficient fuel for the flight. The company had recovered by 1958 and operated scheduled Inclusive Tour (IT) flights to Palma, Perpignan and Basel with a Dakota (G-ANEG), which proved very popular, and they purchased a second Dakota (G-AMSF) in 1959 to enable more European destinations from Elmdon.

Elmdon had often been used as a diversion point for flights diverted away from London airports, much to the delight of local coach operators; the busiest being caused by the infamous London smog in 1952, which brought fifteen flights with 400 passengers diverted in from as far afield as Dublin, Aberdeen, and Oslo. The number of passengers travelling through Elmdon had reached 110,000 by 1955.

The 1960s – Into the Jet Age

Elmdon airport remained under Government control until 2 April 1960, when it again became Birmingham City Council's responsibility and was renamed Birmingham Airport. The new terminal extension to handle international traffic – known as 'The International Building' – was opened on 28 April 1961 by HRH the Duchess of Kent.

RAF Transport Command's de Havilland DH.106 Comet *Cepheus* (XK716) from Lyneham became the first commercial jet airliner to visit Birmingham on 18 April 1961, and Vickers Vanguards – the biggest turboprop aircraft to use the airport – were to become a dominant feature in the BEA fleet as it expanded its services. However, as with the Lockheed Constellation operated by in-house charter airline Euravia (London) Ltd (owned by Captain Ted Langton of the ill-fated Universal Sky Tours), they still could not operate fully-laden because of the runway length.

A further runway extension to 7,400 feet (2,225 m) to facilitate scheduled turboprop and jet airlines and tour operators was completed in 1966, and heralded a jackpot season for airline operators with around 300 jets (which included BEA Tridents, British United Airways BAC 1-11s, Spantax Convair 990 Coranados, and KLM Lockheed Electras) operating from the summer of that year. KLM changed from the Electra to a Dakota DC-9 in 1967 as BEA started serving their Malta route with de Havilland Comets. Air France and Iberia Airlines commenced Sud Aviation SE-210 Caravelle services to Nice and Palma respectively. Work had begun in February 1966 to extend the old terminal but it would soon prove to be woefully inadequate to cope with the rising numbers of passengers.

The 06/24 runway was incorporated into the taxiway in 1967 for aircraft departing the end of runway 33, or gaining access to runway 15. A Caledonian Airways Bristol Britannia was the first transatlantic passenger flight (from Montreal) to land at Birmingham airport after being diverted from Gatwick airport. Freight services continued to expand with BOAC operating Boeing 707s from New York and Seaboard World Airways Douglas DC-8s from Chicago.

British Overseas Airways Corporation (BOAC)'s Vickers Super VC-10 G-ARVE made the airline's first official visit to Birmingham airport to promote the airline's new passenger service to New York in October 1969. Weekly services began in the early 1970s from Birmingham to New York via Manchester but failed to attract the anticipated passenger numbers. It was subsequently routed out via Prestwick and finally stopped in 1973 due to severe losses.

Expansion and Modernisation in the 1970s

In the decade that saw the magic one million passenger mark reached (in 1978), the Inclusive Tour market was rising swiftly and the large number of airlines competing for trade also served to illustrate the competition in the crossover of the generations of airliner development. Air Malta, Channel Airways, Air Spain, Aviaco, Aviogenex, Balair, Braathens, Cyprus Airways, Inex-Adria, JAT, SAM, Spantax, Trans Europa, and World Airways operated flights to Mediterranean hotspots and the USA with aircraft types such as Boeing 720s, DC-7s, DC-8s, DC-9s, Viscounts, and Tupolev TU-134s.

Dan-Air announced a lucrative deal with Global Holidays to cover its entire tour flight programme out of Birmingham starting from April 1971 using BAC 1-11s for flights to Alicante, Gerona, Ibiza, Mahon, Malaga, Palma, Tenerife, and Venice and, in a similar deal reached with the MATO travel consortium, flew passengers to Corfu, Faro, Ibiza, Malaga, Palma, Rhodes, and Tenerife using Comet 4s – their longer-range Comet 4Cs were used in the 199-seat configuration on routes to Los Palmas, Tenerife, and the Greek Islands. By the summer of 1971, Dan-Air was flying for almost all of the major UK tour operators. Laker Airways bought its DC-10 (G-AZZC) – the first wide-body jet to land at Birmingham – on a demonstration flight for the travel trade on 30 December 1972.

Birmingham airport became a major diversion field during the winter of 1972/3 for flights diverted away from the London airports. Forty-five diversions were handled on one particularly busy day with other flights

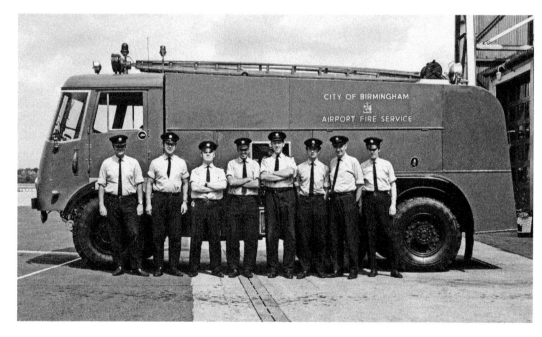

Early 1970s
The City of Birmingham Airport Fire & Rescue Service 'White Watch' Crew. Left to right: White Watch: Derek Houghton, George Smith, Vic Harby, Brian Deacon, Derek Tustin, Brian Wortledge, Mick Wright, Alan Pratt. (Alan Pratt)

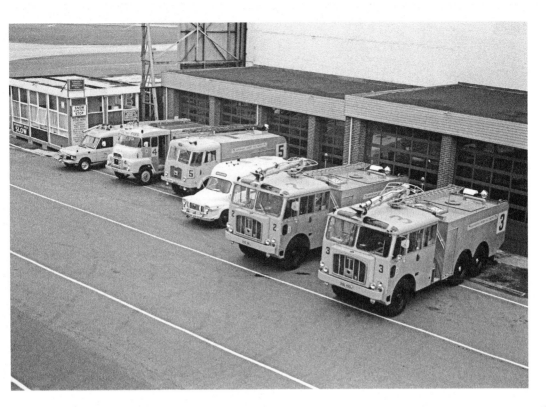

Birmingham Airport fire engines line up in the early 1970s. (Alan Pratt)

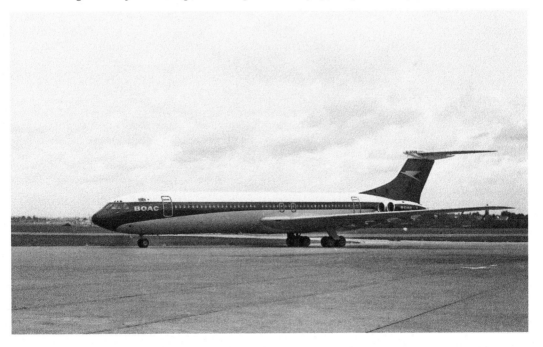

1971
BOAC Vickers Super VC-10 (G-ASGB) 1971. (Author's Collection)

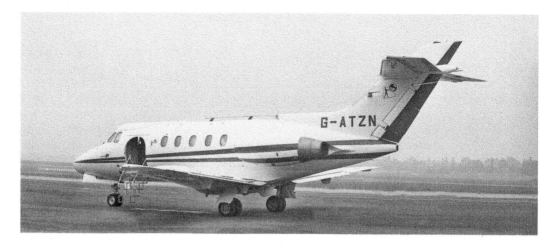

Rank Organisation Hawker-Siddeley HS.125-3A (G-ATZN) in 1971. (Author's Collection)

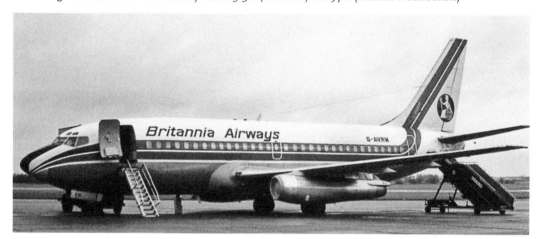

1972
Britannia Airways Boeing 737-204 (G-AVRM) in 1972. (Author's Collection)

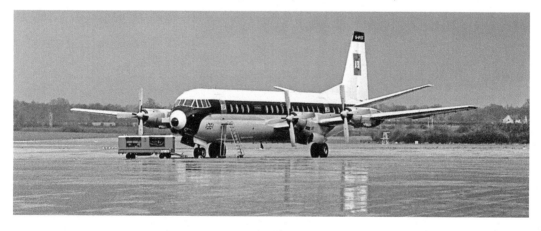

British European Airways Vickers Viscount 953 Vanguard (G-APET) on 27 May 1972. (Carl Ford)

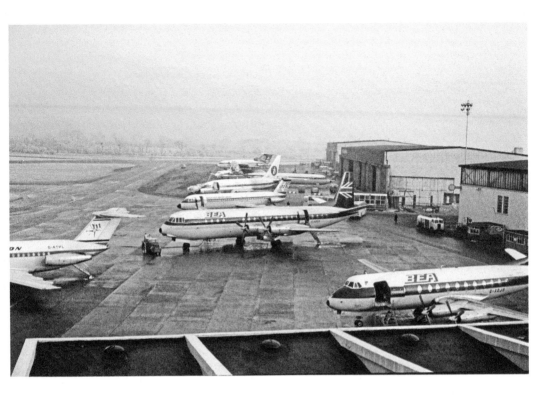

1973
Many aircraft were diverted to Birmingham from the London airports during the winter of 1972/3. (Alan Pratt)

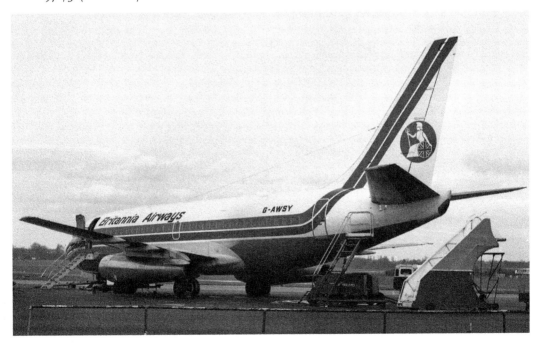

Britannia Airways 737-204 (G-AWSY) in 1973. (Author's Collection)

being turned away. The extra aircraft lined the sides of the runway on occasions, and the transfer coaches struggled to cope with the excess numbers of passengers.

The West Midlands County Council, which was formed under the Local Government Act of 1972, was the upper-tier administrative body for the West Midlands County (comprised of the boroughs of Birmingham, Coventry, Dudley, Sandwell, Solihull, Walsall, and Wolverhampton) and took over ownership of the airport on 1 April 1974.

Birmingham International Railway Station (named after the airport) opened on 26 January 1976 to serve the airport and operate as part of the transport system for the National Exhibition Centre (NEC), which opened a week later on 2 February. Managed by Virgin Trains, the station is now served by Arriva Trains Wales, CrossCountry, and London Midland.

In a bid to gain greater presence at Liverpool Airport, British Airways reached a deal with British Midland Airways (BMA) to exchange its licenses for Birmingham to Copenhagen and its routes to Frankfurt and Brussels for BMA's licences for four routes out of Liverpool that had become huge financial liabilities for the company.

On 4 June 1978 a Qantas Boeing 747-238B 'Jumbo Jet' (VH-EBH) arrived at Birmingham from London Heathrow Airport on a publicity flight, and in doing so became the first aircraft of its type to use the airport. Canadian Pacific Air Lines, operating as CP Air, began operating scheduled flights to Toronto in the following year.

1975
British Air Ferries operated ATL-98 Carvair G-ASDC on the nightly Southend–Birmingham–Speke route on behalf of the GPO in 1975. (Alan Pratt)

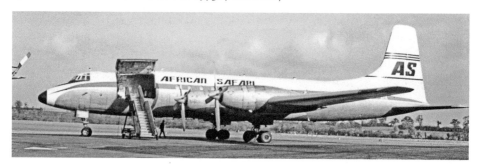

1975 – 1977
African Safari Bristol Britannia 307F (5Y-AYR) operated by African Cargo Airways. The aircraft was broken up at Bournemouth in 1982. (Alan Pratt)

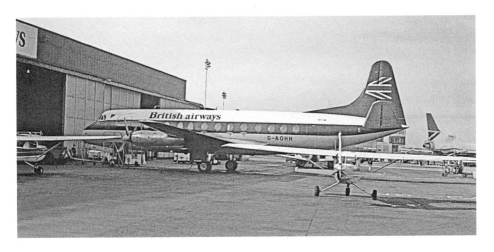

British Airways Vickers Viscount 800 (G-AOHH) outside its maintenance hangar. (Alan Pratt)

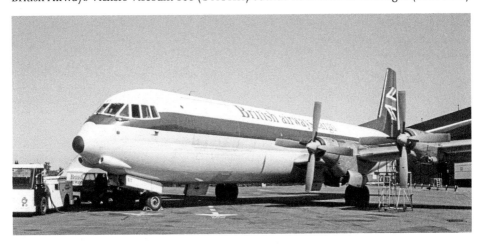

British Airways Vickers 953C Merchantman (G-APET). (Alan Pratt)

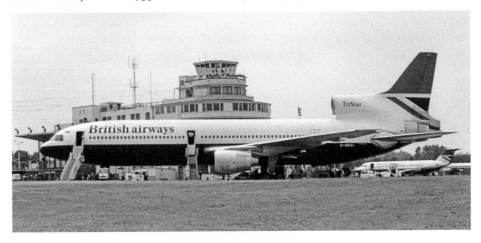

British Airways Lockheed L-1011-1 Tristar (G-BBAI) on the apron. (Alan Pratt)

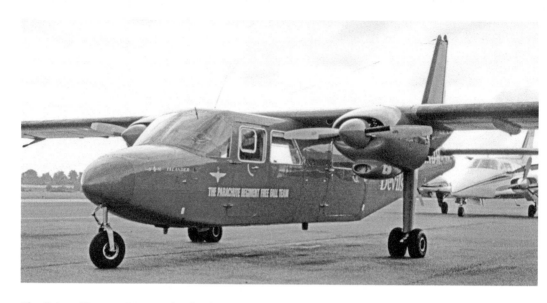

The Britten-Norman BN-2A Islander (G-AXDH) of the 'Red Devils' Parachute Regiment Free Fall Team. (Alan Pratt)

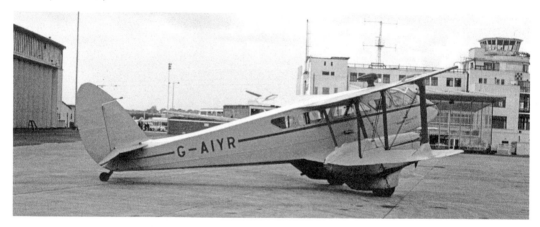

De Havilland DH.89A Dragon Rapide (G-AIYR). (Alan Pratt)

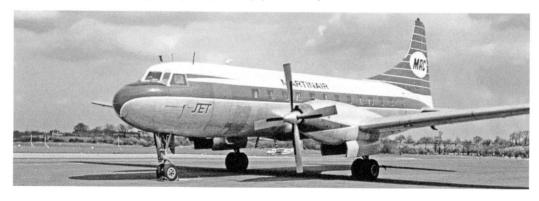

Martin's Air Charter (Martinair) Convair 440-48 Metropolitan (PH-CGD). (Alan Pratt)

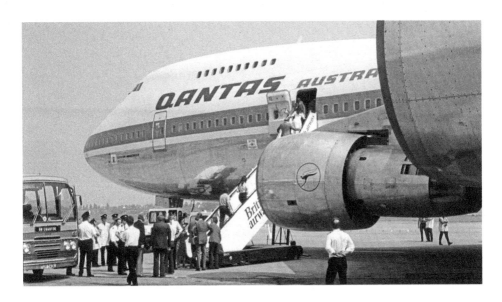

1978
Qantas Airways Boeing 747-238B VH-EBH was the first B747 into Birmingham Airport on a publicity flight from London Heathrow on 4 June 1978. (Alan Pratt)

Britannia Airways B737-204 (G-BAZI) in March 1978. (Alan Pratt)

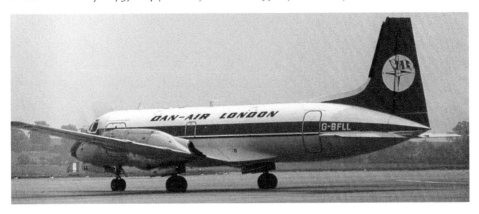

1979
Dan-Air Hawker Siddeley HS.748 (G-BFLL) at BHX on 10 June 1979. (Author's Collection)

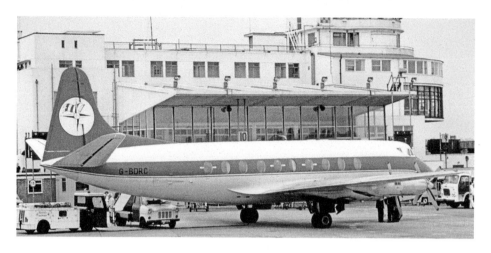

Dan Air Vickers Viscount 700 (G-BDRC). (Alan Pratt)

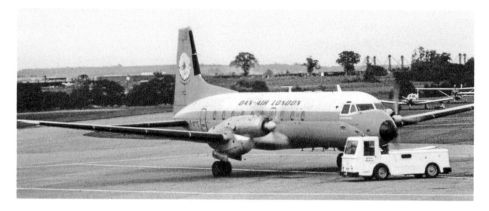

Dan Air Hawker Siddeley HS748 G-AYYG, on lease here from New Zealand's Mount Cook Airlines. The (new) National Exhibition Centre can be seen to the right of the background. (Gordon Bevan)

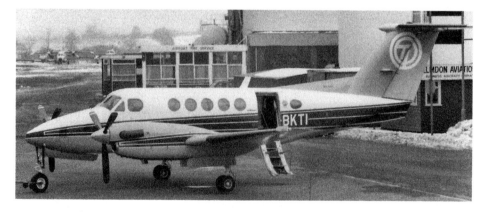

Tube Investments (later known as TI Group) Executive turbo-prop Beech 200 Super King Air (G-BKTI) close to the offices of Elmdon Aviation. Part of the old airport fire station can be seen in the background. (Gordon Bevan)

The 1980s

1980 saw the visit to Birmingham of the first supersonic airliner Concorde (F-BTSC), operated by Air France on a charter flight from Charles de Gaulle airport, Paris, on 16 September. The next Concorde to arrive was British Airways' G-BOAE from Heathrow on 21 March 1982 to showcase its flagship aircraft.

The new £29 million passenger terminal, which had been given the go-ahead in 1980, was built on the east side of the runway, adjacent to the Birmingham International railway station and the NEC, and handed over to the airport on 11 January 1984. The terminal, which was designed to provide more route opportunities for airlines and to handle an anticipated 3 million passengers a year by the end of the decade, was first used on 4 April, and was officially opened by HRH Queen Elizabeth II and the HRH the Duke of Edinburgh on 30 May.

Further development of the area included two island piers, which incorporate twenty aircraft stands – eight of which are for wide-bodied jets – and an 800-space multi-storey car park adjacent to the new terminal. Up-to-date baggage handling and flight information systems were installed, together with shopping, banking, and catering facilities. The domestic lounge is at ground-floor level while international departure lounges are on the first floor, and the main entrance to the new airport has a public stairway tower alongside it to allow separate entrance to the public viewing gallery. The 1939 terminal building gained protection from demolition when it was placed on the Statutory List of Buildings of Special Architectural or Historic Interest.

Following the opening of the terminal, new routes began to open up by international operators including Air France, Iberia, Lufthansa, KLM, Swissair, and Air Canada. However, despite passenger numbers continuing to soar, BEA's dominance at Birmingham airport had begun to flounder in the early 1980s, with many flights being withdrawn, and Air India, which had operated Boeing 707s on twice-weekly services to Delhi and Amristar via Moscow from 1982, closed the route in 1984.

The first ever commercial Maglev (Magnetic Levitation) transport system in the world to be installed at an airport was opened at Birmingham airport on 16 August 1984. With the individual carriages operating at running speeds up to 26 mph, the connecting journey between the airport terminal and the Birmingham International railway station was boasted as taking just ninety seconds. Plans for an electric monorail system to link the airport with the city centre were originally drawn up at the same time that the council approved the construction of the airport in 1936, but the added costs (£500,000) for its installation were prohibitive and the proposal was abandoned.

The shuttles, which hovered 15 mm above the 2,000-foot (600 m) guideway and were able to run at speeds up to 26 mph, were beginning to suffer with electronics problems by the early 1990s and, coupled with a severe lack of replacement parts, led to the system's closure in 1995.

Orion Airways, created in 1978 by Horizon Holidays to support its package holiday business, gained permission in 1986 to fly its Boeing 737-200s on scheduled services from East Midlands and Birmingham airports to various holiday destinations. The airline, which operated seven Boeing 737-300s and two Airbus A300B4s, quickly gained a reputation for its quality of service and was winning customers over the fierce competition. Horizon sold the profitable airline to Bass – the large brewing and hotels group, in 1987 – who in turn received an offer for it by Britannia Airway's owner, the Thomson Travel Group, in August 1988. Thomson had also put forward a bid of £75 million to buy Horizon Holidays and, following the approval of the deal by the UK Monopolies and Mergers Commission in 1989, Thomson merged Orion with Britannia. No concerns were raised that the Thomson Group was owned by the Canadian International Thomson Group, which would subsequently be in control of a large portion of the UK air transport market.

The West Midlands County Council was abolished in 1986 and the ownership of the airport transferred to the newly formed West Midlands Joint Airport Committee, comprising the seven West Midlands district councils. The Airports Act 1986 was introduced and required that municipal airports with turnover greater

than £1 million were to become Public Airport Companies. So, on 1 April 1987, ownership was transferred to the newly created Birmingham International Airport plc – a public limited company, but still owned by the seven councils. True to the projections made at the time the new terminal and its facilities were designed and budgeted for, the decade ended with 3.5 million passengers using the airport.

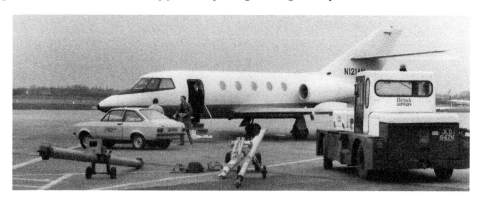

1981

Le Bourget-based Falcon 20E-5 (N121AM) on a charter flight on 4 March 1981. (Gordon Bevan)

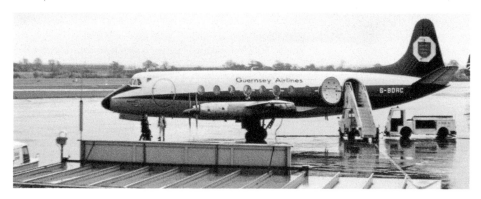

Guernsey Airlines Vickers Viscount 700 G-BDRC (typified by the oval doors) on 3 May 1981. (Gordon Bevan)

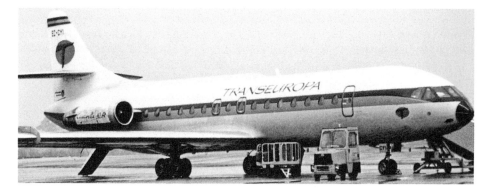

TransEuropa Sud Aviation Caravelle 10R (EC-CYI) on a service to Palma on 10 May 1981. (Gordon Bevan)

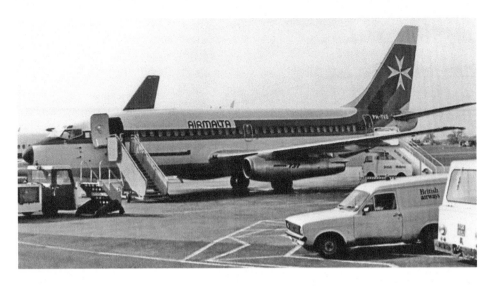

1982
Air Malta Boeing 737-2K2C (PH-TVE) diverted to Birmingham from London Heathrow on 24 February 1982. (Simon Butler)

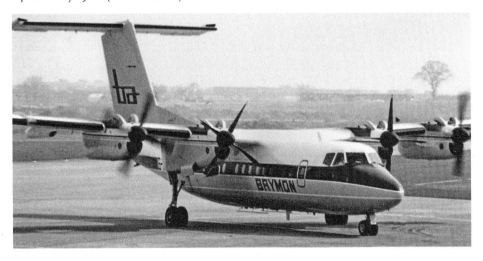

Brymon Airways de Havilland Canada DHC-7-102 Dash-7 (G-BRYB) operating a service to London Gatwick on 3 March 1982. (Gordon Bevan)

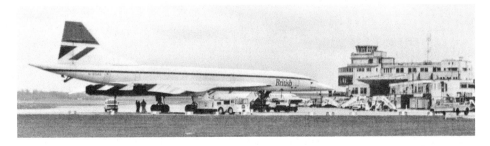

British Airways Concorde (G-BOAE) on 21 March 1982. (Simon Butler)

Balkan (Bulgarian
Airlines) Tupolev
TU-154 (LZ-BTK) on
29 May 1982. (Simon
Butler)

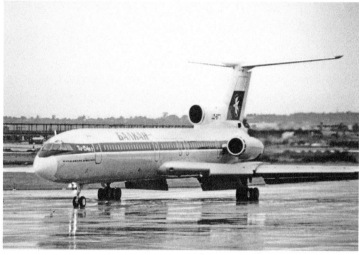

Balkan (Bulgarian
Airlines) Tu-154B-2
(LZ-BTT) operating
the weekly charter
from Varna
International airport
on 12 June 1982.
(Gordon Bevan)

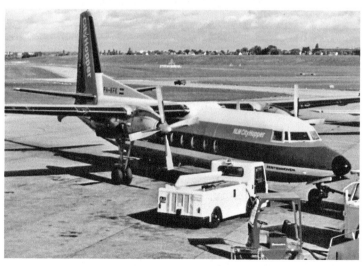

1983
Dutch Aviation
Company (NLM)
City Hopper Fokker
F-27-400 (PH-KFK)
on 5 October 1983.
(Simon Butler)

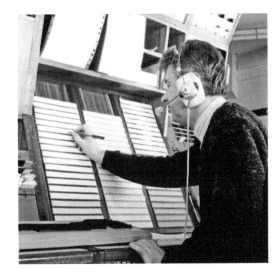

1985/6
A controller using the printed strips that each represent one aircraft with details such as the aircraft's call sign, type, speed, altitude, and destination. (atchistory)

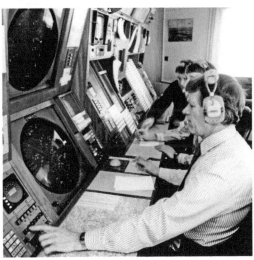

Monitoring of the air traffic control radar scope in the Radar Control Suite showing several aircraft flying in the busy Birmingham Radar Area. (atchistory)

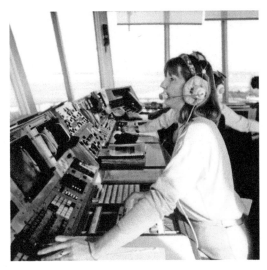

Directing air traffic from the Visual Control Room. (atchistory)

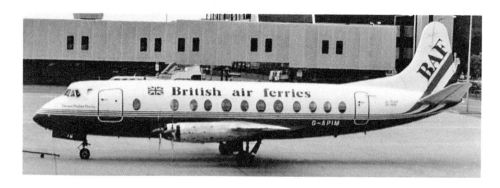

1986

British Air Ferries Vickers Viscount 806 G-APIM on 13 September 1986. The aircraft was damaged beyond repair in an occurrence at Southend Municipal Airport (SEN) on 11 January 1988. (Simon Butler)

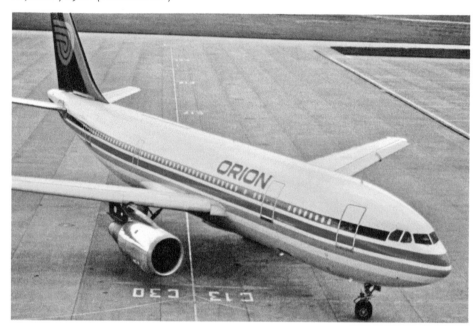

1987

Orion Airbus A300 B4 (G-BMZK) on 16 May 1987. (Simon Butler)

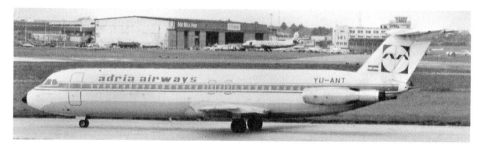

Adria Airways BAC 1-11 (YU-ANT) on 29 May 1987. (Simon Butler)

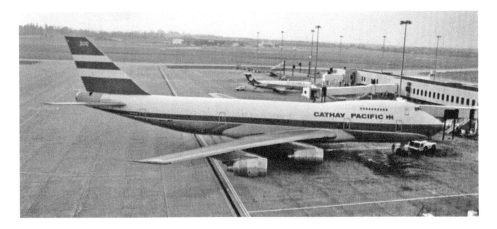

Cathay Pacific Boeing 747 (VR-HIH) on 29 November 1987. (Simon Butler)

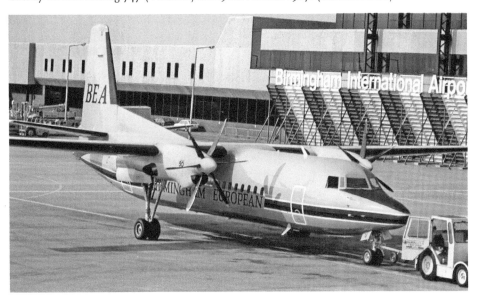

1989
Birmingham European Fokker 50 (OY-MMV) in 1989. (Author's Collection)

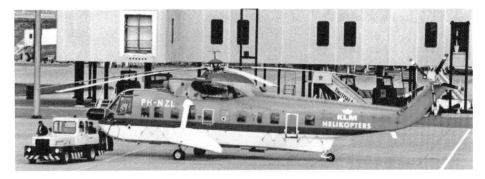

KLM Helicopters Sikorsky S61N (PH-NZL) on 5 June 1988. (Simon Butler)

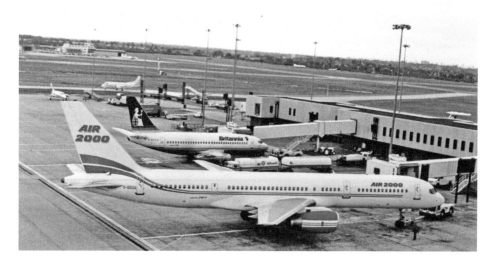

Air 2000 Boeing 757-28A (G-OOOA) on 31 August 1989. (Simon Butler)

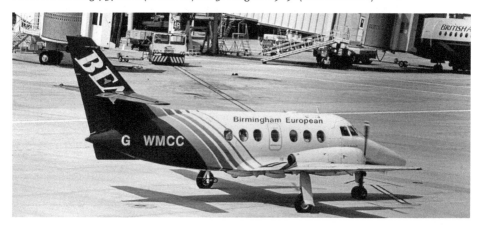

1992
Birmingham European's BAe Jetstream 31 (G-WMCC) in 1992. (Author's Collection)

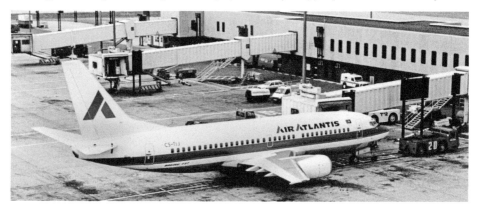

Air Atlantis 737-300 (CS-TIJ) on 19 June 1992. (Steven White)

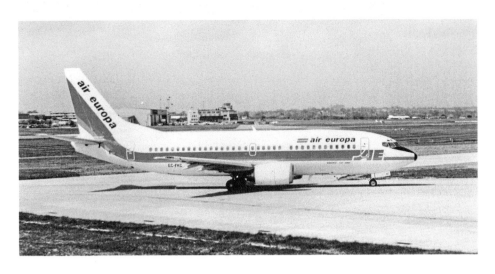

1994
Air Europa 737-300 (EC-FKC) on 22 April 1994. (Steven White)

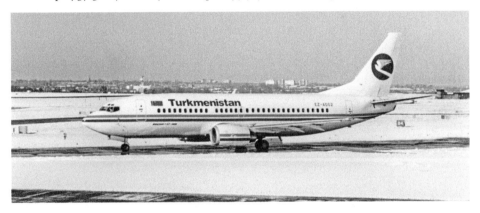

1996
Turkmenistan 737-300 (EZ-A002) and Crossair Avro RJ100 (HB-IXT) on 8 February 1996. When the snowfall began on 5 February, it was expected to melt away by the following morning, but three days later, most of Britain was gripped by a snow-storm followed by sub-zero temperatures that paralysed rail and air traffic. (Steven White)

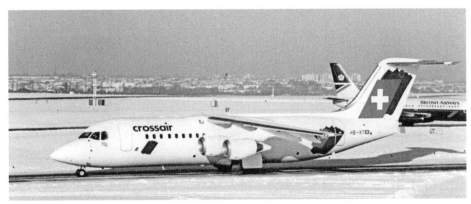

The 1990s

BIA's second passenger terminal, which would become widely known as the 'Eurohub', opened for business on 26 July 1991, with Concorde in attendance. Built under an arrangement by a company comprising Birmingham airport, British Airways, National Car Parks, the local authorities, and John Laing Holdings, it was designed for the use of British Airways and its partners as part of a 'hub and spoke' system – based on a concept that had already been formulated in the USA for their local operations – and it was the world's first terminal to combine passengers from both domestic and European destinations. It also provided a solution to the demands of Immigration and Customs control that, beforehand, necessitated different terminals.

The Government placed a limit on public sector borrowing in 1993, and in response to this, the local authority owners reduced their shareholding to 49 per cent so that BIA became a private company in order to ensure future development plans could go ahead.

President Clinton and other world leaders landed at BIA to attend the 24th G8 Summit held in Birmingham from 15–17 May 1998. British Airways replaced the Boeing 757 that normally operated the daily flights to New York with a Boeing 767 for the event. The route was axed following the terrorist attacks on the World Trade Centre in New York City on 11 September 2001.

Among the new scheduled flights to use BIA in 1998 were Loganair's thrice-daily service to Dundee under a franchise agreement with Flybe, and Koral Blue and AMC Airlines' services to Sharm el Sheikh, Egypt. Ryanair moved their flights to their new base in Terminal 2, which was operational from 17 June. Regular visits were also made by RAF Medivac flights from Afghanistan and Iraq, which bought injured service personnel in on their way to the Royal Centre for Defence Medicine at Selly Oak Hospital, Birmingham.

BIA celebrated its 60th anniversary in 1999 and, by the end of the decade, forty airlines were using the airport, which was seeing annual figures of seven million passengers and 100,000 tons of freight passing through it.

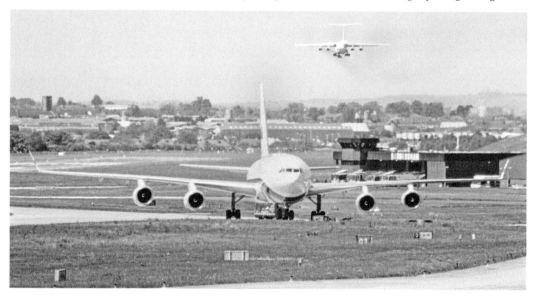

1998
Ilyushin IL96-300 RA-96012 brings the Russian delegation to the 24th G8 Summit, held in Birmingham on 17 May 1998. An Aeroflot IL76MD (RA78817) is arriving in the background. (Chris Chennell)

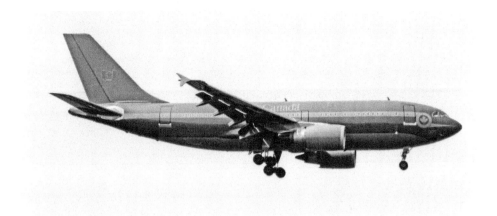

RCAF Airbus A310-300 (CC-150 'Polaris') in May 1998. (Dennis Lau)

Maersk/British Airways 737-500 (G-MSKD) on 18 October 1998. (Steven White)

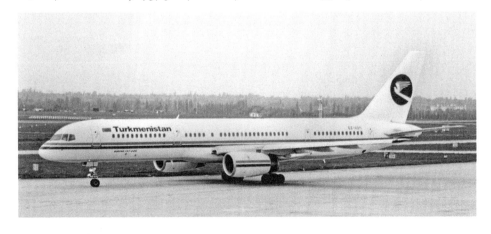

Turkmenistan Airlines Boeing 757-200 (EZ-A011) 1998. (Dennis Lau)

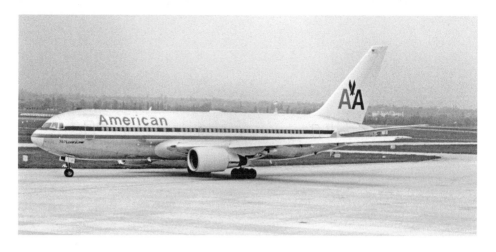

American Airlines Boeing 767-200ER (N320AA) 1998. (Dennis Lau)

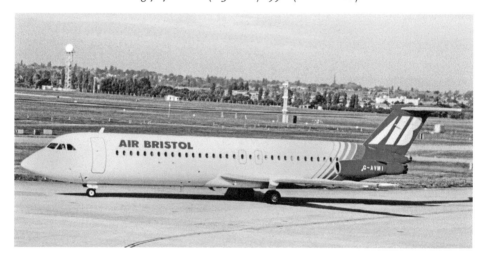

Air Bristol BAC 1-11-500 (G-AVMI) 1998. (Dennis Lau)

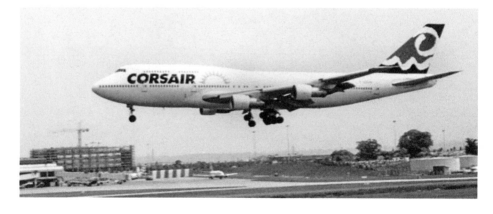

1999
Corsair Boeing 747-312 (F-GSUN) in May 1999. (Author's Collection)

Into The New Millennium

On 3 March 2000, HRH The Queen and HRH the Duke of Edinburgh officially opened the £40 million redevelopment of the airport, which included a new customs and immigration hall, twelve new shops, a new baggage reclaim area, a new arrivals concourse, a new pier with three air bridges, sixteen new check-in desks, and linked Terminal One with Terminal Two (the 'Eurohub') for the first time.

Pakistan International Airlines (PIA) launched a new twice-weekly Boeing 747-300 service to Karachi in 2000 but, because runway was not long enough to sustain a fully fuelled, fully laden 747, operated via Copenhagen. The route was made direct in the following year by a downgrade of aircraft. PIA went on to start a twice-weekly service linking BIA with Islamabad and Chicago in 2003, along with their existing Lahore – Birmingham – Toronto route, but these services were subsequently axed and moved to Manchester. Currently, PIA operates a four-times-weekly Islamabad–Birmingham operation using Boeing 777s – the largest aircraft to regularly serve Birmingham.

Emirates made its debut in the region on 18 December 2000 when it started a daily non-stop service from Dubai to BIA using a 278-seat Airbus A330-243 (A6-EEA), which was named *City of Birmingham* for the occasion, and also established Emirates SkyCargo – the freight division of Emirates – to help regional businesses export products to destinations all over the world.

In 2003, the old Maglev transport system, which had been dormant since its closure in 1995, was replaced with SkyRail – an Austrian-built 1,919 foot (585 m), twin-track, fully automated cable-hauled funicular; another first in the world for an airport. Built over the existing Maglev guideway, the construction project took two years to complete and was opened for public use on 7 March. The individual cars, which can carry up to twenty-seven passengers, run every few minutes each way and has a passenger-operated 'demand' button for use at off-peak times.

Concorde G-BOAC made her final visit to BIA on 20 October 2003, where she flew over, circled around, and landed as part of her farewell tour.

A new turn-off from the main runway was completed in June 2006, which saw an improvement in traffic rates on southerly operations; previously the only available option for landing traffic had been to travel to the end of the runway to exit.

BIA won the Airports Council International (ACI) Award for excellence in airport operations in June 2007 when it was voted the best airport in Europe in the 5–10 million passengers per year category and, following a comprehensive consultation process with local communities, the airport went on to publish a master plan for the airport titled *Towards 2030: Planning a Sustainable Future for Air Transport in the Midlands* in November 2007. This set out the details of changes to the terminals, airfield layout, and off-site infrastructure, and was not received without controversy. Plans for a second runway on the other side of the M42 motorway as well as a new terminal building and business park were also published.

British Airways had been losing money with their CitiExpress regional operations from five UK airports (including BIA) and, despite re-branding it as the low-cost airline BA Connect, failed to reverse the trend as Ryanair and EasyJet continued to attract the lion's share of low-cost-no-frills flights. British Airways sold the subsidiary airline to Flybe in 2007, which still offered flights to a number of destinations using Dash-8 Q400s and an Embraer ERJ-195, based at the airport.

The 06/24 runway was decommissioned in January 2008 to allow work to be carried out on the expansion of the aprons on both sides of the runway and in June work began on building the new three-storey International Pier – the first investment of its kind in over twenty years. Passengers would be accommodated on the top level, arriving passengers on the middle level, and office accommodation for the airline and handling agents on the ground floor.

The £45 million International Pier, designed by Pascall & Watson Architects, was officially opened on 9 September 2009 – the airport's 70th anniversary – and significantly increased the airport's aircraft handling capabilities; being able to accommodate seven wide-bodied aircraft (including the Airbus A380 and A350, the larger aircraft types such as the Boeing 787 Dreamliner and the Boeing 777), and thirteen smaller ones via air-bridged access.

The milestone event was also marked with the first arrival of Emirates Airlines A380-800 (A6-EDE) and became the first UK airport outside London Heathrow to play host to the mighty double-deck Airbus A380 in passenger service. The first visit by an A380 took place on 5 September 2009 when *Airbus Industrie* A380-841 F-WWOW made an approach and circuit as part of a UK tour.

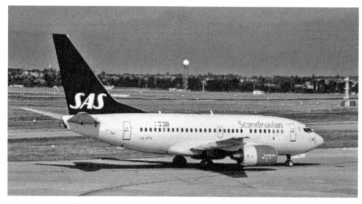

2002
SAS Airlines Boeing 737-683 (LN-RPA) on 15 August 2002. (Author's Collection)

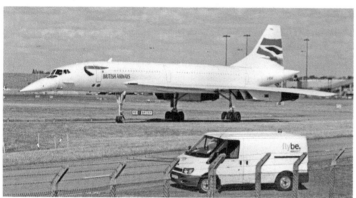

2003
Aerospatiale-BAC Concorde (G-BOAC) on 20 October 2003. (Dennis Lau)

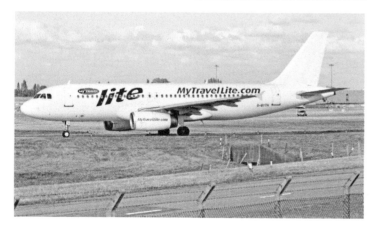

MyTravel Lite Airbus A320-200 (G-BYTH) on 20 October 2003. (Dennis Lau)

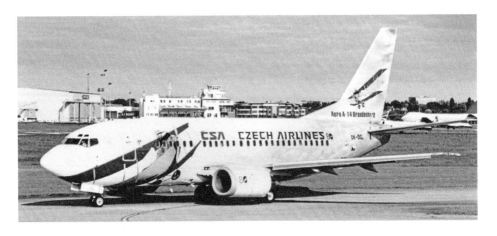

Czech Airlines 737-500 OK-DGL on 26 May 2003 with in special livery to celebrate the airline's 80th anniversary. (Steven White)

2005
SAS Scandinavian Airlines Canadair CRJ-900 (OY-KFL) on 20 May 2014. (Chris Chennell)

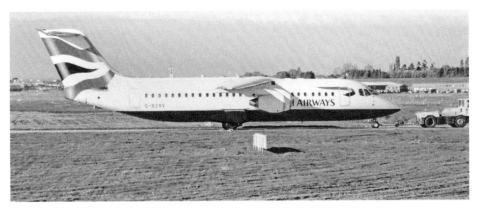

2006
British Airways CitiExpress BAe Avro RJ100 (G-BZAV) being towed across the runway on 4 November 2006. (Martin Jones)

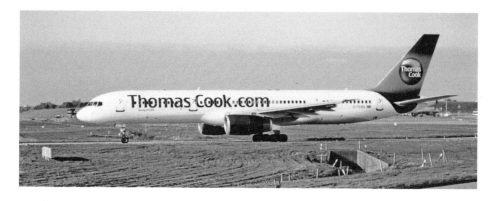

Thomas Cook Boeing 757-200 (G-TCBA) on 4 November 2006. (Martin Jones)

The Old Birmingham Terminal on 11 November 2006. (Martin Jones)

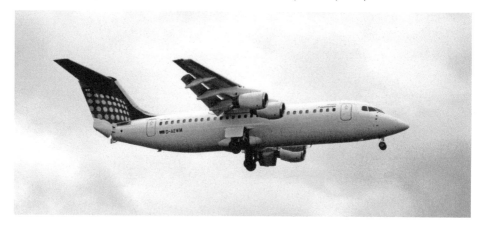

Eurowings BAe 146-300 (D-AEWM) on approach 11 November 2006. (Martin Jones)

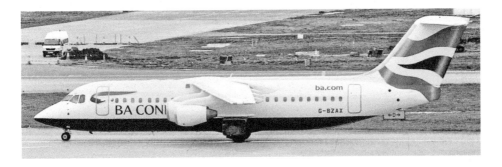

BA Connect BAe 146-RJ200 (G-BZAX) on 31 March 2006. (John Boardley)

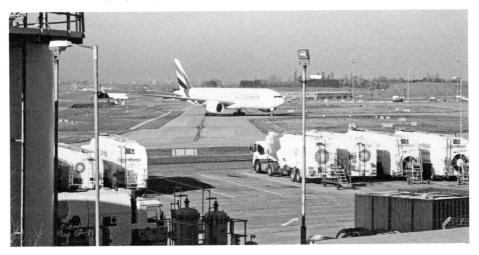

2007

The Air BP and Exxon Mobile Aviation Fuel Farm at Birmingham airport on 3 February 2007. An Emirates Boeing 777 is in the background with a Thomas Cook Boeing 757 in the distance. (Martin Jones)

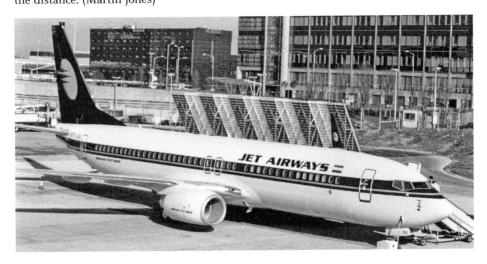

Jet Airways Boeing 737-800 (VT-JGU) on 7 February 2007. (Simon Butler)

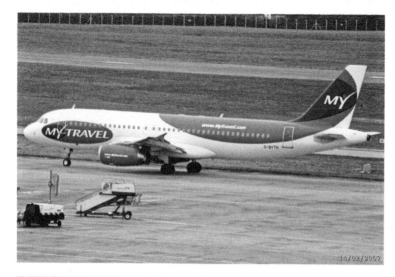

MyTravel Airbus A320-231 (G-BYTH) on 14 February 2007. (Simon Butler)

A busy apron on 6 April 2007. First Choice Airways Boeing 757-2YO G-CPEP is in the foreground with a Monarch Airbus A321-200 behind. (Simon Butler)

BAE 146-300 Flybe (G-JEBG) in April 2007. (Steven White)

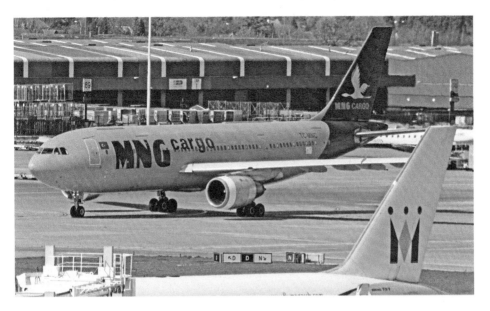

MNG Airlines Cargo Airbus A300F (TC-MNC) on 6 April 2007. (Simon Butler)

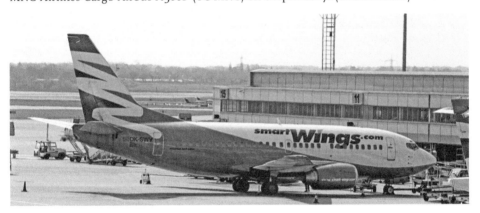

Smart Wings Boeing 737-500 (OK-SWV) on 6 April 2007. (Simon Butler)

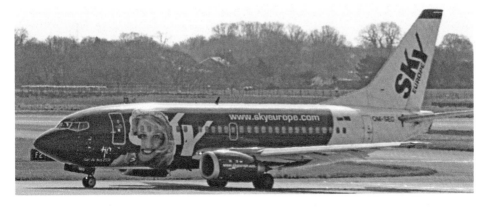

Sky Europe Boeing 737-500 (OM-SEG) on 6 April 2007. (Simon Butler)

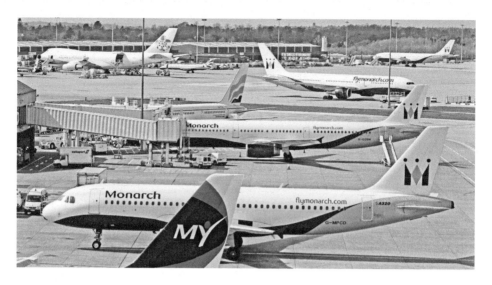

Monarch Airlines Airbus A320-212 (G-MPCD) with Airbus A321-231 (G-OZBM) on 6 April 2007. (Simon Butler)

British Airways Embraer 145 (G-EMBX) (G-EMBS) and City Jet Bae 146 (EI-CNB) heading the line-up on 25 April 2007. (Simon Butler)

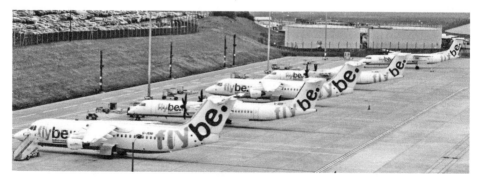

Flybe line-up headed by BAe 146-200 (G-JEBO) and de Havilland Canada DHC-8-402 Dash 8-400 (G-JEDB) on 25 April 2007. (Simon Butler)

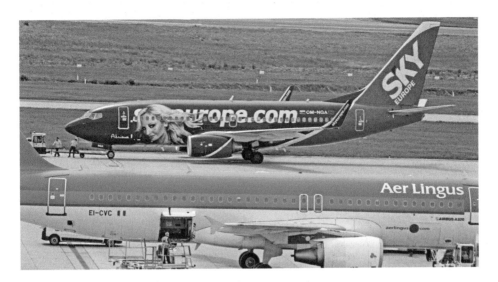

Aer Lingus Airbus A320-214 (EI-CVC) and Sky Europe Boeing 737-700 (OM-NGA) on 28 May 2007. (Simon Butler)

2008
Air India Express Boeing 737-800 (VT-AXV) on 17 January 2008. (Simon Butler)

Thomson Airways Boeing 757-204 (G-BYAH) and Monarch Airlines Airbus A321-231 (G-OZBF) on gates on 30 May 2008. (Neil Halford)

RAF Lockheed L-1011-500 Tristar (ZE-704) on 22 August 2008. Having also flown for Pan Am as N508PA until November 1984, it went into storage in March 2014. (Simon Butler)

2009
Centre Avia Yak 42 (RA-42423) on 13 February 2009. (Simon Butler)

Turkish Airlines Airbus A319-132 (TC-JLV) on roll, 12 March 2009. (Neil Halford)

bmibaby Boeing 737-36N (G-TOYF) waiting for take-off on 12 March 2009. (Neil Halford)

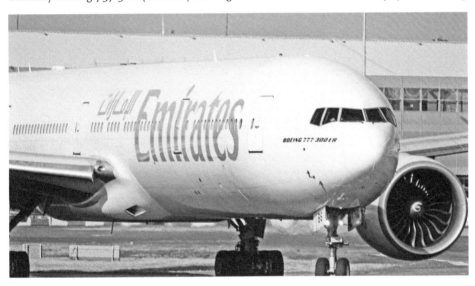

Emirates Boeing 777-300ER on 12 March 2009. (Neil Halford)

A busy stand on 13 April 2009. (Neil Halford)

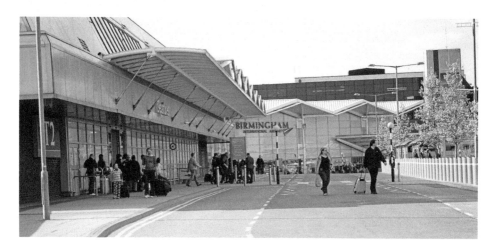

Terminal entrance on 13 April 2009. (Neil Halford)

The new terminal extension at Birmingham Airport on 1 June 2009. (Martin Jones)

United Arab Emirates taking to the air on 1 June 2009. (Martin Jones)

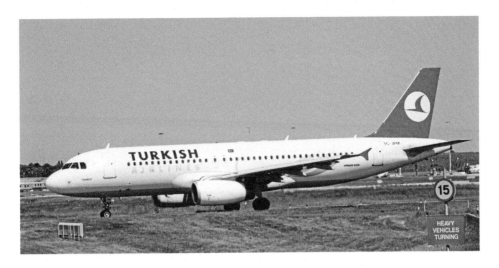

Turkish Airlines Airbus A320-232 (TC-JPM) on 1 June 2009. (Martin Jones)

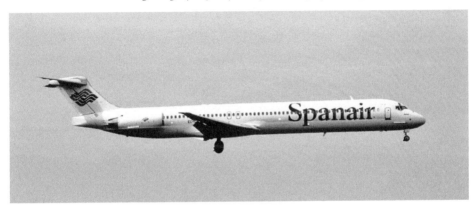

Spanair McDonnell Douglas MD-83 (EC-GVI). (Author's Collection)

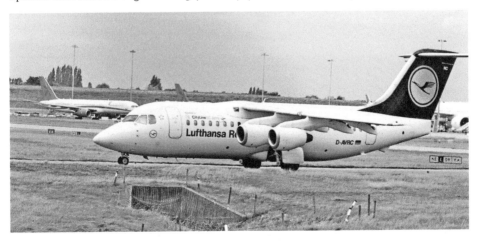

Lufthansa CityLine BAe Avro RJ85 (D-AVRC) on the taxiway ready for take-off from Runway 33 on 5 September 2009. (Neil Halford)

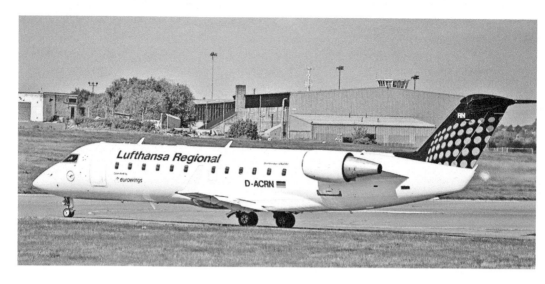

Lufthansa Regional jet CRJ-200 (D-ACRN) on the taxiway at preparing for take-off on 9 September 2009. (Neil Halford)

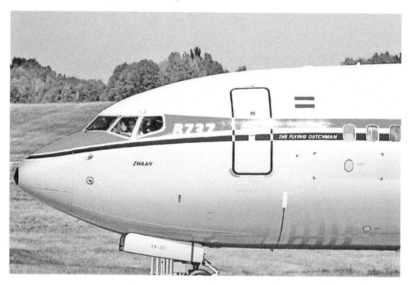

KLM (Royal Dutch Airlines) Boeing 737-800 *The Flying Dutchman* (PH-BXA) in original colours at Birmingham International Airport on 9 September 2009. (Neil Halford)

A Flybe Dash 8 on a quiet apron at Terminal 2 on 5 September 2009. (Neil Halford)

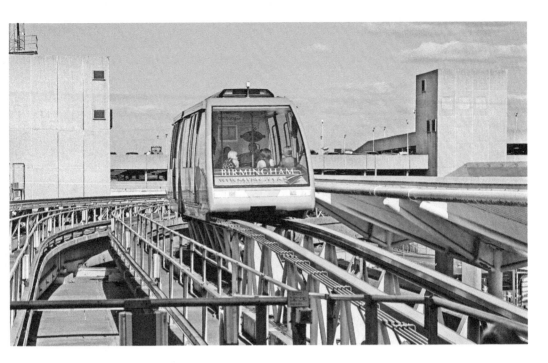

The Air-Rail monorail transport system between the railway station and Birmingham International Airport on 9 September 2009. It replaced the earlier Birmingham Maglev system in 2003. (Neil Halford)

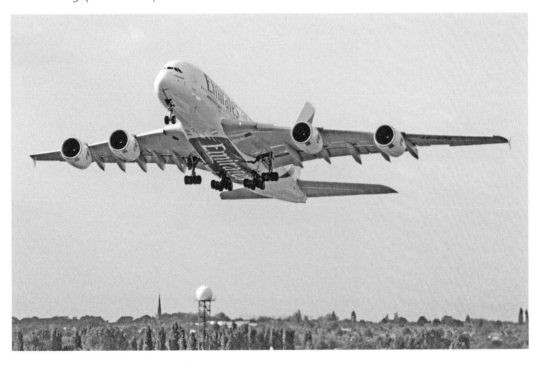

Emirates Airbus A380 (A6-EDE) on 9 September 2009. This was the first arrival of an A380 into a UK airport other than Heathrow and marked the airport's 70th anniversary. (Simon Butler)

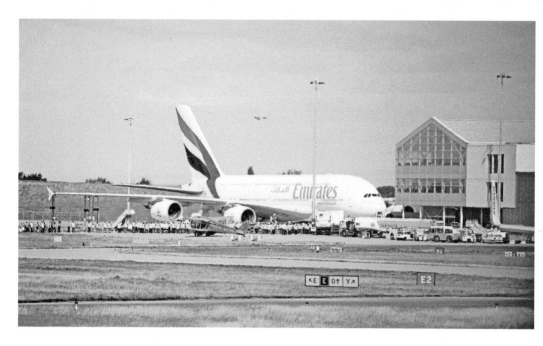

An Emirates Airbus A380 on the apron during the celebrations of the airport's 70th anniversary and opening of New Pier on 9 September 2009. (Neil Halford)

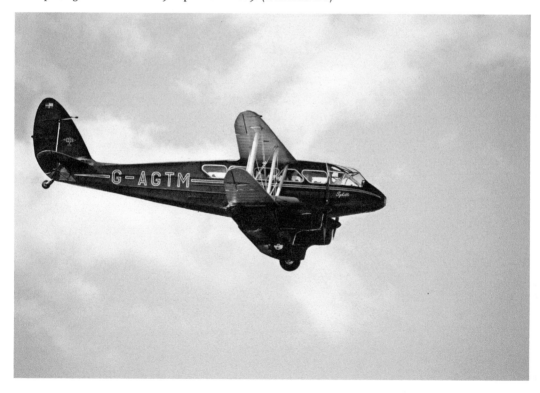

de Havilland DH.89A Dragon Rapide *Sybille* (G-AGTM) coming into land on runway 33, en route to joining the airport's 70th anniversary celebrations on 9 September 2009. (Neil Halford)

Brussells Airlines BAE-146 (OO-DJT) approaching runway 33 on 9 September 2009. (Neil Halford)

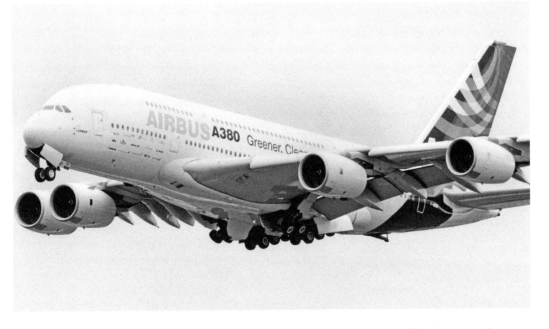

Airbus Industrie A380-841 F-WWOW performs a missed approach at Birmingham on 5 September 2009. (Martin Hartland)

2010 To Today

Cello Aviation (part of the Gill Group) launched its executive air transport operations from BIA in 2010 with a forty-six-seat BAe 146 146-200 (G-RAJJ) *Frank Kane* and an eighty-two-seat RJ85 (G-LENM). On 17 May 2011 it flew Her Majesty the Queen to Dublin (in G-RAJJ) as part of her four-day historic State Visit to the Republic of Ireland, and in March 2013 the company – which has Coldplay, Jennifer Lopez, and Christina Aguilera among its list of famous passengers – reluctantly turned away The Rolling Stones after refusing to allow one of the ageing rockers to smoke on board. A Boeing 737-400 (G-RAJG) was added to its fleet in 2015.

Following the approval by Solihull Metropolitan Borough Council of plans submitted in January 2008, the airport opened its new £13 million Terminal 1 facility in May 2011. The two original terminals had been merged to provide enlarged arrivals facilities, new walk-through duty and tax free stores, along with new high street-branded shops, bars, and restaurants, as well as a new Centralised Security Search area. The taxiways were also improved to allow for the terminal expansion and to improve runway occupancy rates.

As part of a major rebranding effort aimed at encouraging more of the 8 million Britons living within one hour of the airport to use it for their air travel needs, BIA dropped the 'International' from its title and, on 5 November 2010, the new name started to be used. The new logo of interlocking circles in shades of blue and slogan – 'Hello World' – were designed to reflect the airport's new positioning as a global travel hub.

As a further part of a £200 million package, construction work began on a 1,312-foot (400 m) runway extension in March 2012, which would bring the West Coast of America, South America, the Far East, and South Africa into the scope of the airport in terms of long haul flights – connecting flights to feed the long haul network and increased demand for cargo freight movement. Following compulsory purchase orders issued and negotiated to acquire the necessary extra land, contractors VolkerFitzpatrick and Colas were jointly appointed for the realignment and improvement of 1.2 miles (2 km) of the A45 Transport Corridor Improvement (to reduce unnecessary long distance surface journeys to other UK airports and generate sustainable long-term economic growth inside its own local area) and the runway extension work, which included resurfacing the entire runway and making modifications to the existing fuel farm, as well as the construction of a new taxi-way exit, the installation of new aircraft ground and approach lighting, and the construction of a new airfield perimeter road. The runway was closed to all arriving and departing traffic during that phase of the project from Tuesday 5 November 2012 until 5 April 2013.

As the airport grew, the controllers in the 1939-built ATC tower were unable to have an adequate view of the airfield, the terminal, and piers, so work on a new tower designed by Nottingham Architects CPMG was started in May 2011 under the auspices of Morgan Sindall plc. The new single seven-storey circular tower, which stands at 111 feet (34m) tall and includes an internal lift shaft and dividing walls, was constructed by Northfield Construction Ltd using the 'Slipform' construction technique, whereby concrete was poured continuously over a twelve-day period into a moving steel shutter, which was lifted by hydraulic jacks in a slow, continuous movement allowing the concrete to harden sufficiently by the time it emerged from the bottom of the form. Slipforming, compared to other traditional building methods, reduced the construction time by four weeks. The sixteen-sided Control Room comprises three distinct operational elements – a high level Visual Control Room (VCR), an Approach Control Room (ACR), and a Main Equipment Room (MER) that houses the main avionics equipment, which was prefabricated off-site and lifted into place at the top of the tower by crane. The tower was then finished with external cladding and the construction was completed in March 2012.

A ceremony was held at the airport on 23 April 2012 with the unveiling of the Olympic Rings that had been fitted to the new ATC tower to commemorate the build-up to the London Olympic Games. Following this, the control tower's avionics and specialist ATC equipment was installed and, after testing and training,

became operational on 17 April 2013. It was crowned 'Project of the Year' and won a further award for the best 'Regeneration' scheme at the 2013 Royal Institution of Chartered Surveyors (RICS) West Midlands Awards.

The Runway 15 Instrument Landing System (ILS) was replaced in 2013 while work on the runway extension was progressing. The alternative Non-Directional Beacon approach was employed, which, although safe, is less precise; it is offset from the ILS approach by approximately five degrees and provides guidance to the pilot until such time as visual contact with the runway is established. Some aircraft, however, were able to continue to fly along the usual centre-line using an APV/Baro procedure, which provides the vertical guidance during the approach.

A new 110,000-square-foot maintenance facility was completed in 2013, which supports up to 300 new jobs – mostly highly skilled engineering roles – and has the capacity for the maintenance of the Boeing 777 Dreamliner and Airbus A350, as well as being able to hold two wide-bodied Boeing 777-300ER aircraft or ten narrow-body aircraft.

The long-awaited runway extension was completed on 27 May 2014 and the first plane to travel to the Far East from Birmingham Airport – China Southern Airlines' 248-seat A330-200 flight to Beijing – took off on 22 July, marking the start of the only UK to China direct air route to operate from outside London. In 2012 the Chinese visitor market was worth £62 million to the West Midlands economy, with Birmingham now the fourth most popular destination for Chinese visitors in England.

Birmingham Airport celebrated its 75th anniversary on 8 July 2014 with a flypast by the Rolls-Royce Supermarine 389 Spitfire PR19 (G-RRGN). The month was coincidentally the busiest to date in the airport's history, with 1.1 million passengers passing through.

A special contact number as part of the Vortex Protection Scheme at Birmingham Airport was created for homeowners under the flight path in the Kitts Green area close to the runway end who have had their pitched roofs damaged – i.e. roof tiles dislodged and/or sucked from the roof – by vortex winds created by landing aircraft. Many required re-roofing over the previous five years. A study was carried out by Kinetic (who have worked with the Ministry of Defence) into the nature of vortex strikes and, although the findings were inconclusive, they could confirm that less than 0.01 per cent of flights cause vortex damage. The problem is not unique to Birmingham Airport; other major airports support similar schemes, and London Heathrow funded a £15 million voluntary Vortex Protection Scheme in which every house, school, church or hospital affected by a Heathrow vortex strike is eligible for vortex protection.

Emirates opened a £1.3 million lounge at BIA in 2010 for its First Class, Business Class, and Gold Skywards members, and increased capacity by 22 per cent over the summer by introducing a larger Boeing 777-300ER aircraft onto its evening flight, and added a third daily service in 2015. Since they started the route in 2000, they have carried over five million passengers between Dubai and Birmingham. Emirates Airbus A380 (A6-EOR) made the inaugural flight from Birmingham on 27 March 2016 ahead of the three daily flights to Dubai that began a week later.

OAG, the air travel intelligence company, named Birmingham Airport the world's most punctual airport in 2016, with 91.28 per cent of the 100,000 scheduled flights arriving and departing flights operating on time. OAG's punctuality league is based on approximately 54 million flight records using full-year data from 2016.

The leading leisure airline and package holiday companies Jet2.com and Jet2holidays began flights and holidays from Birmingham airport on 7 July 2016 – operating Boeing 737-800s with fifty-seven weekly flights planned for the summer of 2017. The new Cypriot airline Cobalt Air launched a twice-weekly service with Airbus A320-214 (5B-DCR) from Larnaca, Cyprus to Birmingham Airport on 10 December 2016.

British Airways returned to Birmingham Airport in January 2017, following a ten-year absence after selling its regional airline BA Connect to Flybe in 2007, to launch new routes for the summer (Ibiza, Florence, Malaga, and Palma) using ninety-eight-seat Embraer 190 jet aircraft. New routes were also introduced by bmi Regional with a twice-weekly flight to Graz, Austria on 27 February from its new base at Birmingham airport, with routes to Nuremberg, Germany and Gothenburg, Sweden starting on 8 May.

Birmingham airport opened in 1939 with the aim of creating jobs and stimulating industry in the region, and it entered 2017 drawing in record-breaking monthly passenger figures, with January being the busiest

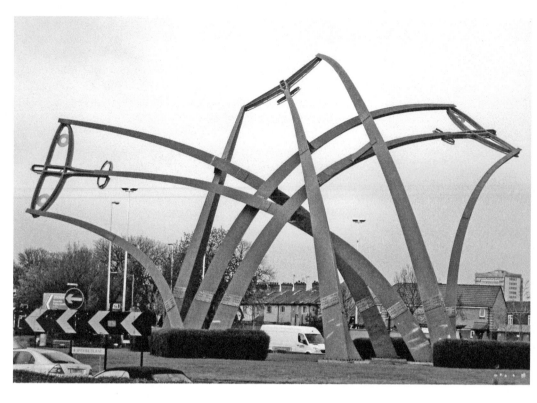

2010

The Sentinel monument on Spitfire Island, Castle Bromwich. (Roland Turner)

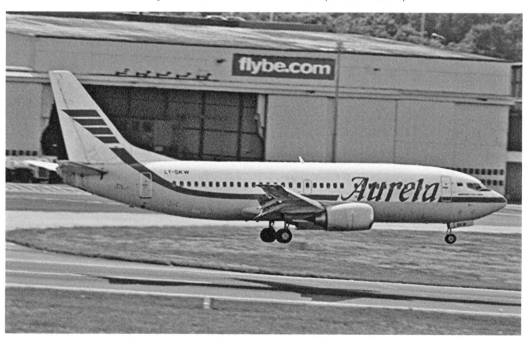

Aurela Boeing 737-300 (LY-SKW) on 15 August 2010. (Simon Butler)

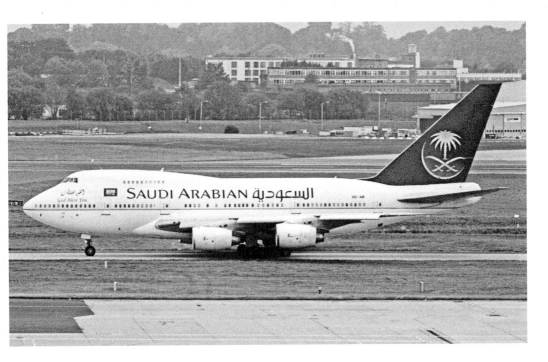

Saudi Arabian Boeing 747SP-68 (HZ-AIF) on 14 October 2010. This aircraft was part of the Saudi Arabian Royal Flight and was the first 'SP' variant of the Boeing 747 to land at Birmingham. (Simon Butler)

2011
A Contrac Cobus 3000 on airside duties on 12 July 2011. The shuttlebus has a maximum capacity of 112 passengers and provides the quickest way of moving passengers to remote aircraft parking positions. (Kieran Marshall)

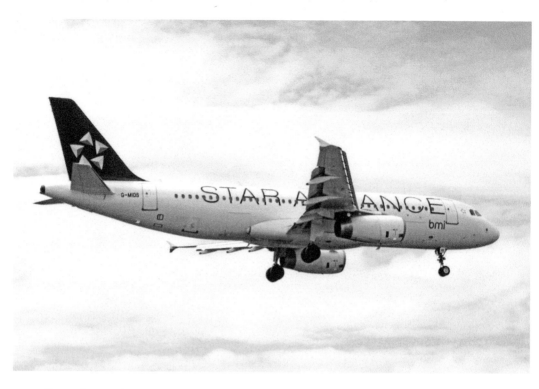

Star Alliance bmi Airbus A320-232 (G-MIDS) on 15 July 2011. (Simon Butler)

Aer Lingus Airbus A320-214 (EI-DVM) in retro livery on 19 July 2011. (Simon Butler)

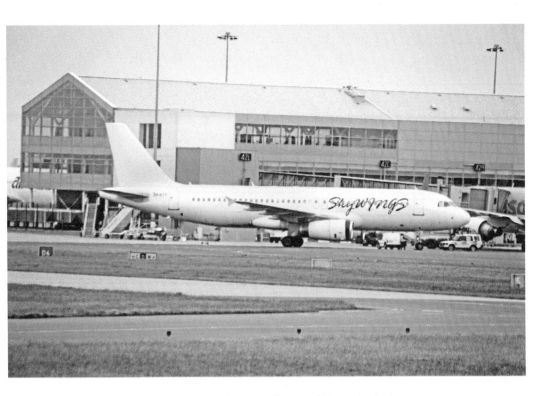

Sky Wings Airbus A320-231 (SX-BTP) on 19 July 2011. (Simon Butler)

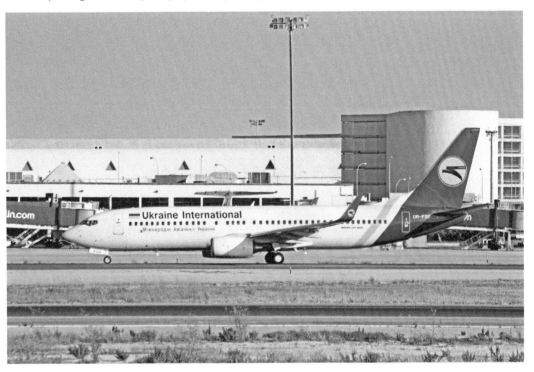

Ukraine International 737-800 (UR-PSD) on 28 July 2011. (Steven White)

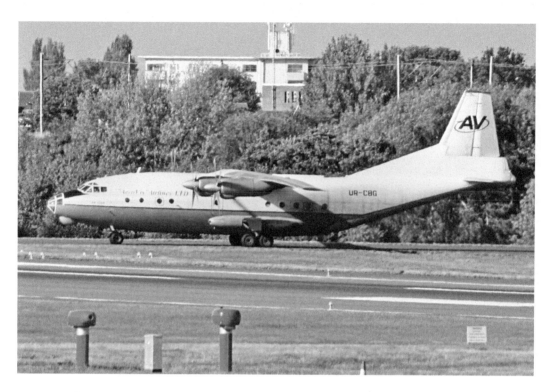

Aerovis Airlines Antonov AN-12-BP (UR-CBG) on 29 September 2011. (Simon Butler)

Emirates Boeing 777-31H(ER) (A6-EBZ) on 19 November 2011. (Simon Butler)

2012
A Busy Terminal 2 apron on 19 January 2012. (Simon Butler)

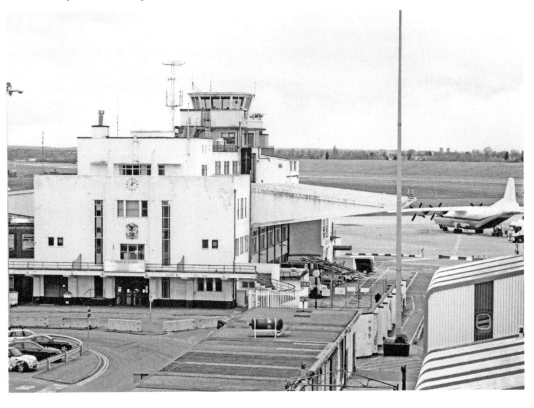

Elmdon Airport on 15 February 2012. Beyond is a Meridian Aviation Antonov An-12BP (UR-CAK). (Chris Chennell)

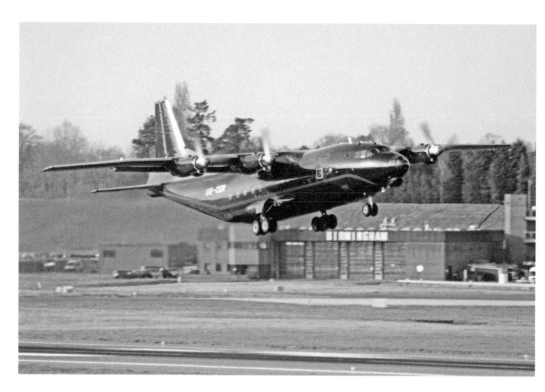

Meridian Airlines Antonov An-12BK (UR-CGV) departing for Bratislava on 21 March 2012. (Chris Chennell)

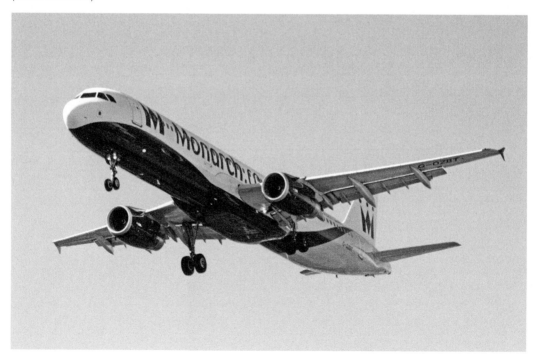

Monarch Airbus A321-231 (G-OZBT) on 26 March 2012. (Simon Butler)

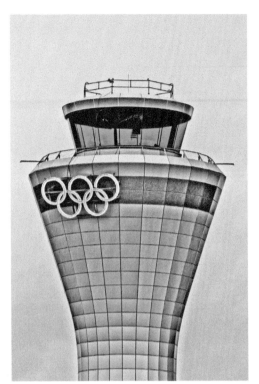

Right: Olympic Rings fitted to the new ATC Tower on 19 April 2012 for the build-up to the London Olympic Games. (Andy Katsaitis)

Below: The new International Pier on 29 May 2012. (Daniel Taylor)

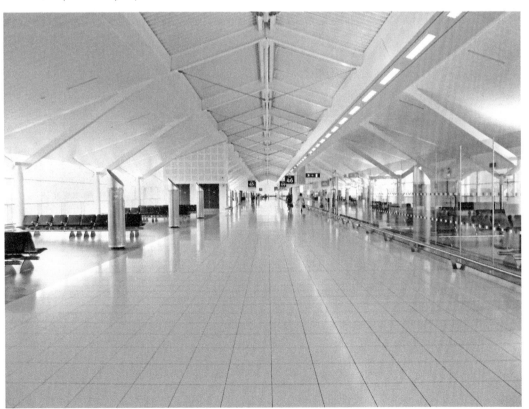

The Air-Rail Link from Birmingham International Station to the terminal building on 29 May 2012. (Daniel Taylor)

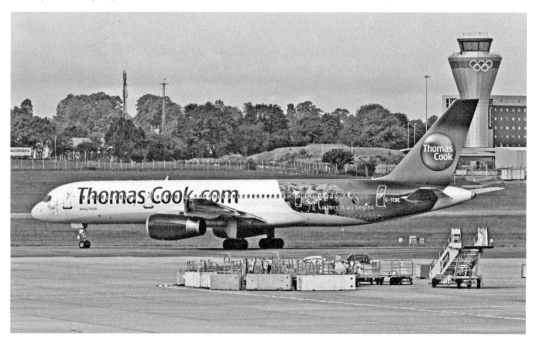

Thomas Cook Boeing 757-236 (G-TCBC) on 6 June 2012. (Simon Butler)

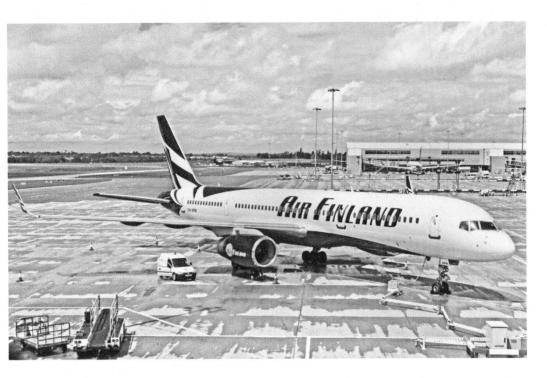

Air Finland Boeing 757-204 (WL) (OH-AFM) on 6 June 2012. The WL variant carried 'winglets' – near vertical wing end-plates designed to control wingtip vortices. (Simon Butler)

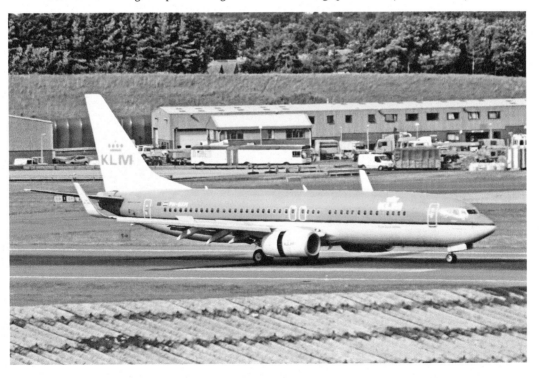

KLM Boeing 737-8K2 (PH-BXM) on 1 August 2012. (Dave Lenton)

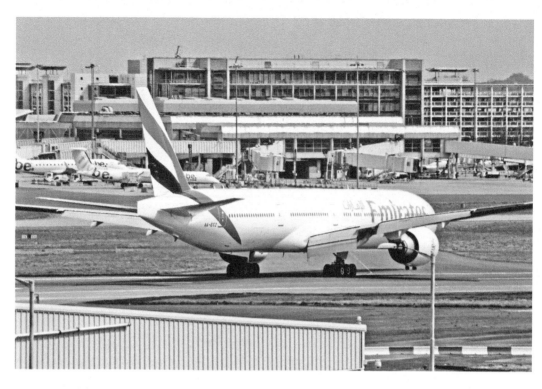

2013

Emirates Boeing 777-31HER (A6-ECZ) on 22 April 2013. (Dave Lenton)

Cessna Citation 550 (G-MHIS) with work in progress on the new ramp/apron in front of the Monarch Engineering hangar in the background on 24 May 2013. (Alec Wilson)

Cello Aviation BAe 146-200 (G-RAJJ) and Avro RJ85 (G-LENM) on 2 June 2013. (Dave Lenton)

A view of the of the 1939 Elmdon terminal and apron at Birmingham Airport on 26 August 2013. (Mark Edwards)

start to the year on record, having handled 775,176 passengers. Year-on-year growth rates increased with Long-haul flights up by 29.5 per cent and Short-haul flights up by 13.4 per cent and plans are in hand to maximise the airport's catchment area with the HS2 high-speed trains serving Birmingham from London – raising its potential from 25 million to over 60 million in the future. As part of the £50 billion project, new stations are to be built at Curzon Street and Birmingham Interchange to serve both the airport and the NEC in time for the first phase (between London and the West Midlands), which is due to open in December 2026.

Terminal 1 is the original and main terminal with eighty-six check-ins, thirty-one gates, seventeen airbridges, and ten baggage claim belts, and has the bulk of the airlines, which as of December 2016 are: Aer Arann, Aer Lingus, Air France, Air Malta, Air Slovakia, bmi Regional, Brussels Airlines, City Airline, Continental Airlines, Cyprus Airline, Eastern Airways, EasyJet, Emirates, Eurocypria, KLM Royal Dutch Airlines, KTHY (All Cyprus Turkish Airlines), Lufthansa, Mahan Air, Monarch, Onurair, Pakistan International Airways, SAS, Swiss, Thomas Cook Airlines, Tomson Airways, Turkish Airlines, Turkmenistan, and US Airways. Ryanair and Flybe are the only airlines that fly out from Terminal 2.

A packed remote apron with diverted aircraft from Bristol and London Gatwick from the previous evening's storms alongside Ryanair's winter-parked aircraft on 24 December 2013. (Alec Wilson)

2014
Air Bright Antonov AN.26 (LZ-ABR) on the apron still wearing its special colours for the making of the film *The Expendables 3* on 12 February 2014. (Alec Wilson)

Lufthansa Boeing 737-500 (D-ABIN) on 22 February 2014. (Alisdair Anderson)

Ryanair Boeing 737-800 (EI-DWV) passing the runway extension works shortly before landing on 22 February 2014. (Alisdair Anderson)

Thomson Boeing 737-800 (G-FDZW) taxiing out with a Swiss Air A320 closely following on 22 February 2014. (Alisdair Anderson)

United Boeing 757-200 (N58101) on 22 February 2014. (Alisdair Anderson)

Easyjet Airbus A319 (HB-JZI) on 22 February 2014. (Alisdair Anderson)

Flybe Dash-8 (G-JECP) on 22 February 2014. (Alisdair Anderson)

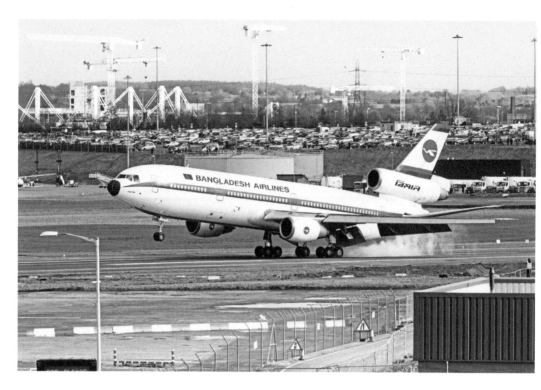

Biman Bangladesh Airlines McDonnell Douglas DC-10-30 (S2-ACR) on 22 February 2014. (Alisdair Anderson)

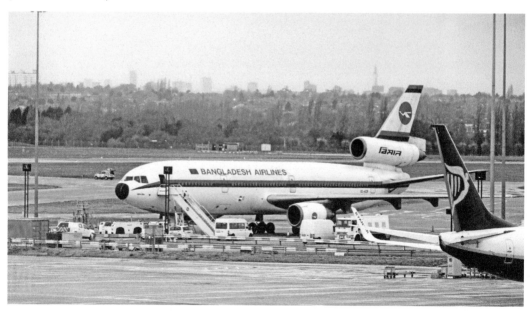

Biman Bangladesh Airlines McDonnell Douglas DC-10-30 (S2-ACR) on 23 February 2014. S2-ACR stopped off at Birmingham for photo opportunities as part of its 'Enthusiasts' Scenic Flights' between 22 and 24 February before it finally retired as the last operational DC-10, to be succeeded by Boeing 777s. (Martin Jones)

Brussels Airways Bombardier DHC.8-402 (OE-LGC) on 24 February 2014. (Dave Lenton)

Ryanair Boeing 737-8AS (WL) (EI-ENA) on Runway 33 in front of the fire station on 9 April 2014. (Dave Lenton)

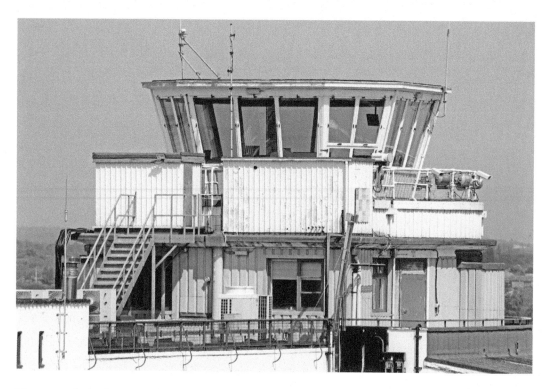

The original Elmdon control tower on 20 May 2014. (Chris Chennell)

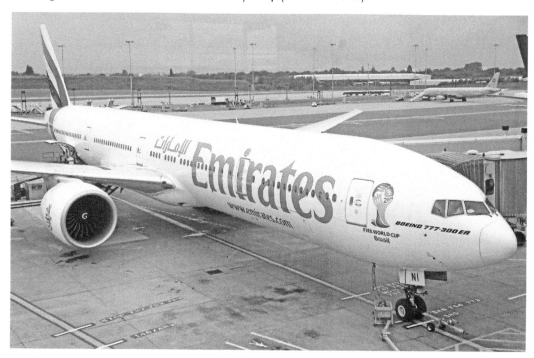

A uniquely decorated Emirates Boeing 777-300ER (A6-EGE) as the Official Flight Sponsor of the FIFA World Cup in Brazil on 14 June 2014. (Neil Halford)

Monarch Airlines Airbus (ZB-446) getting ready for flight to Gibraltar on 9 November 2014. Behind can be seen a Flybe Dash 8 (G-ECOH). (Neil Halford)

Two Beech 300 Super King Air 350s with Brussels Airlines de Havilland DHC-8-402Q Dash 8 (G-ECOI) in the background. Photo taken from the old Elmdon terminal building on 7 December 2014. (Neil Halford)

Monarch Airlines Boeing 757 (G-MONK) on the ramp in front of Monarch's engineering hangar on 20 December 2015. (Alec Wilson)

2015
GainJet Aviation 62-seat VIP Boeing 757-23N (SX-RFA) departing from runway 33 on 2 January 2015. (Alec Wilson)

A Ryanair Boeing 737 waiting to depart on 6 April 2015. (Neil Halford)

Virgin Atlantic Airbus A320-214 *Queen of the Cobbles* (EI-DEO) on the apron waiting to take off for Dublin on 6 April 2015. (Neil Halford)

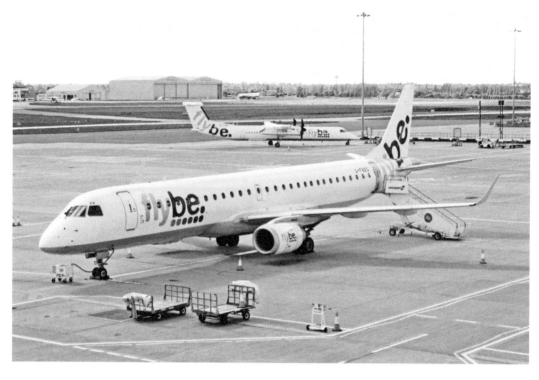

FlyBe Embraer EMB.190-200LR ERJ-195 (G-FBEG) on 28 April 2015. (Dave Lenton)

Silk Way Airlines Ilyushin IL-76TD-90VD (4K-AZ100) on 3 July 2015. (Chris Chennell)

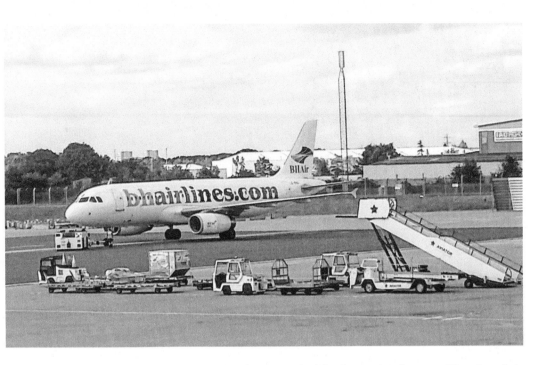

BH Airlines Airbus A320-232 LZ-BHH being pushed back on 18 July 2015. The aircraft is currently on lease by VietJetAir. (Neil Halford)

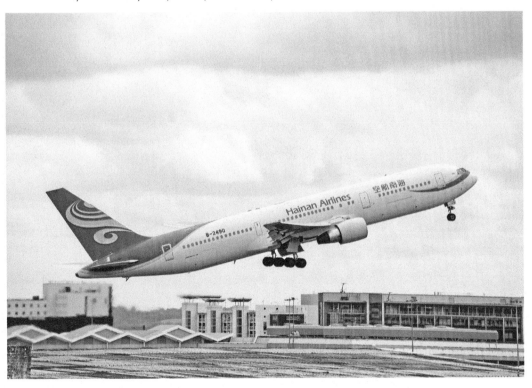

Hainan Airlines Boeing 767-3 (B-2490) departing from runway 15 on 6 July 2015. (Alec Wilson)

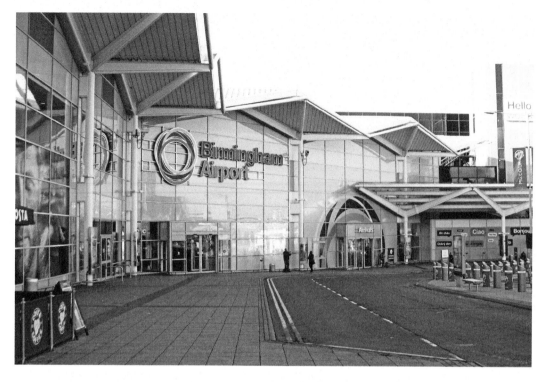

The terminal building on 31 October 2015. (David Cooke)

2016

Thompson Airways Boeing 757-2G5 (G-OOBN) arriving on stand 11 September 2016. (Neil Halford)

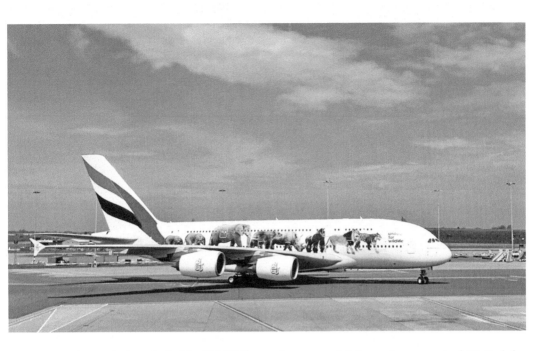

An Emirates Airbus A380-861 (A6-EEQ) wearing a special livery in support of 'United for Wildlife' on 8 May 2016. Applied by Emirates' in-house staff, the design spans over 42.5 metres in length and 6.2 metres in width, and took a team of twenty-eight people 2½ days to apply the decals. (Neil Halford)

Flybe Embraer ERJ-175STD (ERJ-170-200) (G-FBJG) awaiting clearance for take-off on 22 March 2016. (Neil Halford)

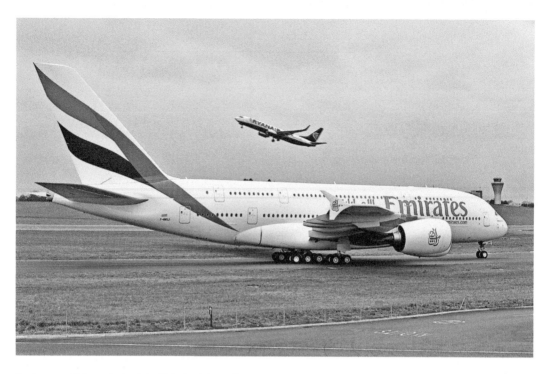

Emirates Airbus A380-861 (F-WWSJ) with a Ryanair Boeing 737 taking off from BHX on 22 March 2016. (Neil Halford)

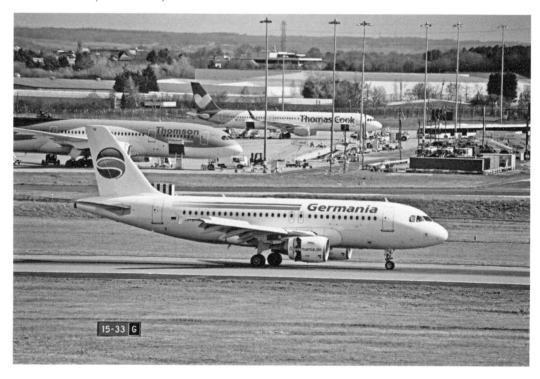

Germania Airbus A319-112 (D-ASTR) arriving on runway 15 on 9 April 2016. (Alec Wilson)

Ryanair Boeing 737 at Birmingham Airport on 12 March 2016. (Neil Halford)

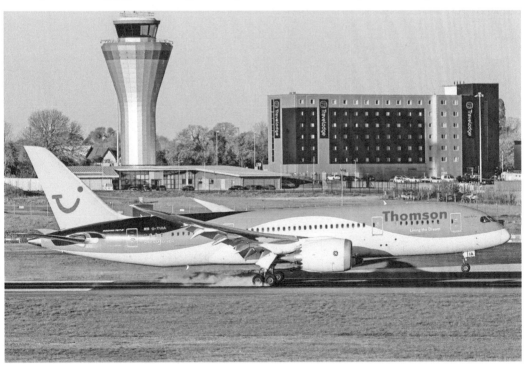

Thomson Boeing 787 (G-TUIA) landing at Birmingham Airport on 23 April 2016. (Fay Jordan)

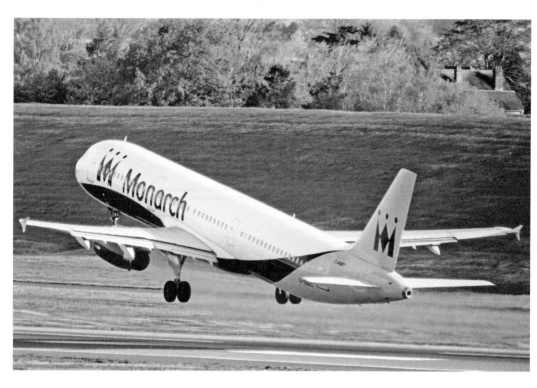

Monarch Airlines Airbus A321-231 (G-ZBAG) on 30 April 2016. (Dave Lenton)

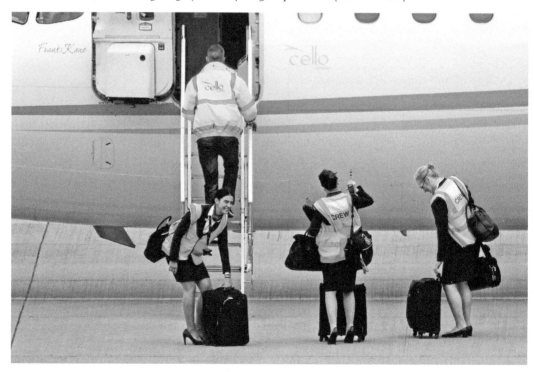

Cello Aviation Crew boarding their VIP jet on 2 May 2016. (Dave Lenton)

Egyptian Air Force CASA C-295M SU-BSE/1188 on 1 July 2016. (Chris Chennell)

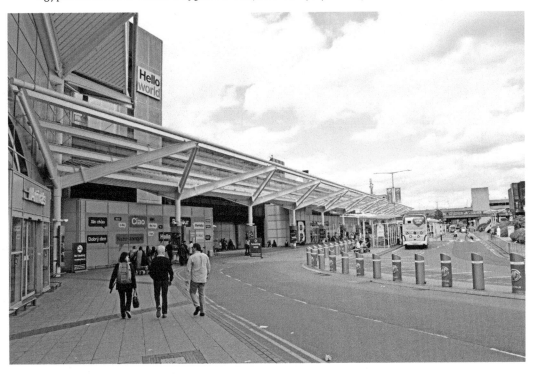

Birmingham Airport Terminal entrance, 3 July 2016. (Steve Green)

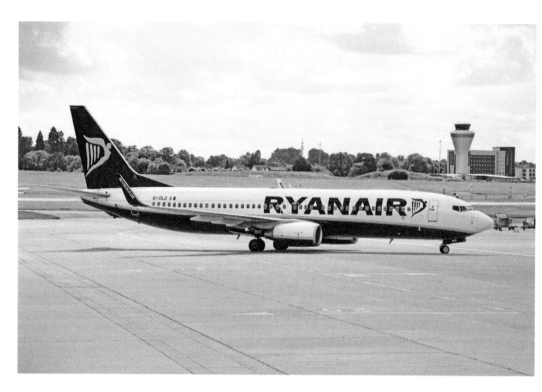

Ryanair Boeing 737-800 (EI-DLD) on flight FR1122 from Tenerife 3 July 2016. (Steve Green)

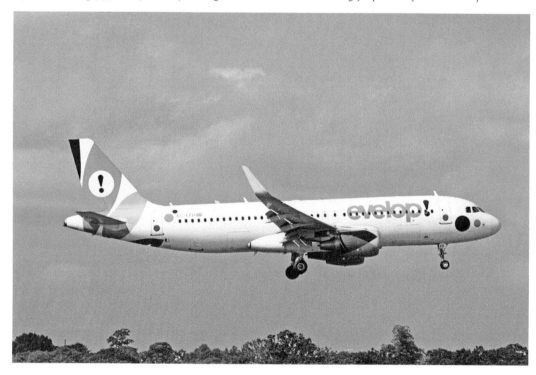

Evelop Airbus A320 (EC-LZD) on 23 July 23 2016. (Steven White)

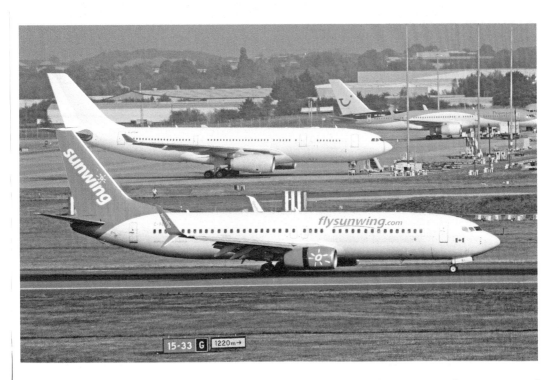

Sunwing 737-800 (C-FBAK) on 14 September 2016. Behind can be seen an Airbus A330-200 of Air Tanker Ltd (G-VYGM). (Steven White)

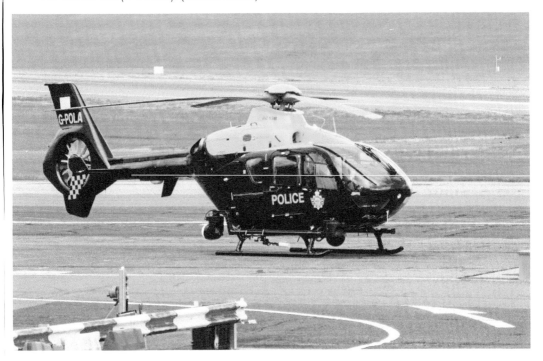

National Police Air Service (NPAS) Birmingham Eurocopter (G-POLA) on 21 September 2016. (Dave Lenton)

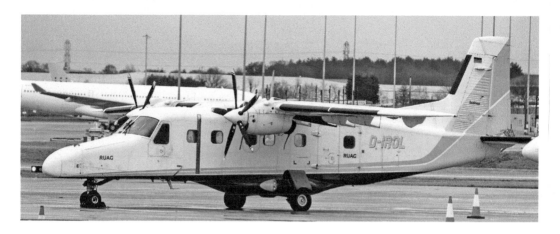

2017
Business Wings Dornier Do.228 (D-IROL) on 1 January 2017. (Alec Wilson)

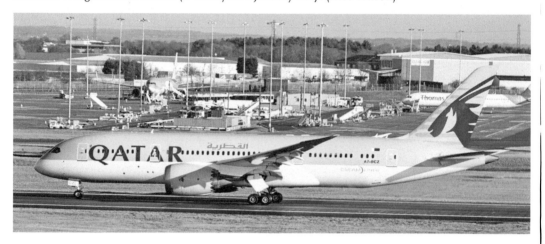

Qatar Airways Boeing 787-8 Dreamliner (A7-BCZ) departing runway 33 on 2 January 2017. (Alec Wilson)

The National Police Air Service (NPAS)

A base was set up at Birmingham airport for the NPAS and was operational from 1 October 2013, with the 2010-built Eurocopter EC-135P2+ (G-POLA) being the most frequent resident for the 'Eye in the Sky' serving Warwickshire, West Mercia, and Staffordshire. Ten of the twenty-five NPAS bases in the UK will be closed over the next two years as part of the measures by the police to save up to £11 million after a huge cut was made to its budget. The newly structured service will operate with nineteen rotary and four fixed-wing aircraft.

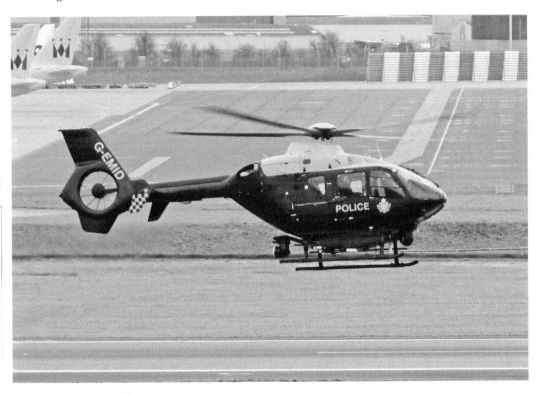

The twin-engine Airbus Helicopters Eurocopter EC13 (G-EMID) at Birmingham Airport on 3 February 2017. (Dave Lenton)

Rescue & Fire Service

Five new state-of-the-art Oshkosh Striker fire fighting vehicles supplied by Terberg DTS (UK) Ltd were unveiled in July 2013 as part of a £3 million replacement vehicle programme to provide greater fire suppression, safety, and versatility to maximise emergency response. The vehicles are all 6x6 axle configuration with all-wheel independent suspension and rear steering system, and powered by a 700HP Tier 4i/Euro-5 emissions-compliant turbocharged engine, which is mated to a seven-speed electronic automatic transmission for smooth power delivery and a top speed greater than 70 mph (113 km/h). Three of the five Birmingham Striker vehicles are equipped with 'Snozzle' extending booms, which can penetrate an aircraft fuselage in the event of an incident, allowing direct and close range access to an on-board fire.

Currently, Birmingham airport is an RFF (Rescue Fire-Fighting) Category A9, which covers aircraft with a wingspan greater than 61 m but less than 71 m – i.e. up to the size of an Airbus A340-500/600.

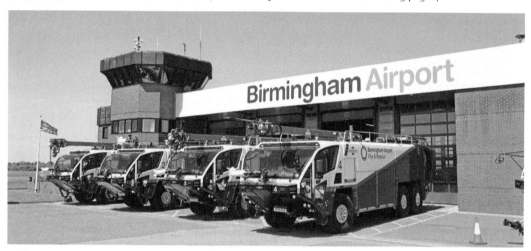

Birmingham Airport Fire and Rescue Oshkosh 1 to 4 line-up. (Mark Platt)

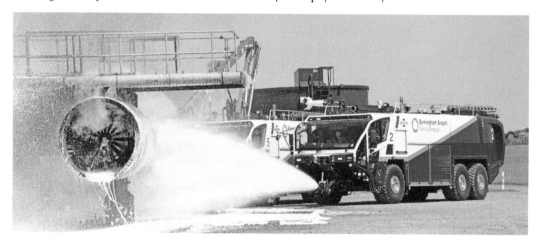

Birmingham Airport Fire and Rescue Oshkosh 2 in training on 17 May 2014. (Mark Platt)

Air Accidents at Birmingham Airport

The port main undercarriage of a British Midland Airways Vickers Viscount (G-AZLR) collapsed upon landing at Elmdon Airport on 9 January 1973, causing the aircraft to skid off the runway and onto the grass. There was no fire and nobody was injured but its proximity to the runway led to the airport being temporarily closed.

A Beechcraft 95-B55 Baron (G-AZUJ) was returning to Elmdon on the foggy night of 20 November 1975. Three unsuccessful approaches were made using the Instrument Landing System (ILS) but on each occasion the pilot made an overshoot. After initiation of the third overshoot the aircraft lost height and struck the ground 670 feet to the right of the runway and 4,800 feet beyond the threshold. The aircraft caught fire and was destroyed. The pilot, co-pilot and its two passengers were killed.

On 21 March 1985, Cessna F150L Reims G-AZHF left Prestwick en route to Croydon when a low oil pressure necessitated a diversion to Liverpool, where the problem was rectified. The Cessna took off again without refuelling and, shortly after making contact with Birmingham Approach Control, the pilot declared an emergency with a rough running engine. He was lined up for an approach to Runway 15 when the aircraft lost power. The pilot initiated a landing in the dark on to a football pitch but at the last moment he stalled the aircraft and caught a tree, cartwheeling into the roof of a warehouse in Fortnum Close, Kitts Green. The pilot suffered minor injuries but the aircraft was written off. The cause of the accident was fuel starvation due to empty tanks.

Donington Aviation Ltd Cessna 404 Titan G-BKTJ, carrying one crew and eleven passengers, crashed on take-off from Birmingham Airport en route to Norwich Airport on 27 November 1985 when it failed to gain sufficient airspeed to gain altitude. The aircraft came to rest in an allotment at the end of the runway with four of the occupants sustaining serious injuries. The subsequent Air Accidents Investigation Branch (AAIB) report attributed the accident to accumulated icing on the wings and flying controls.

A Canadair CL-600-2B16 Challenger 604 (N90AG), on lease to Epps Air Service by the American agricultural equipment manufacturer AGCO Corporation, crashed on take-off from runway 15 at Birmingham on 4 January 2002. The aircraft had arrived the previous evening from Palm Beach International airport and parked overnight at Birmingham, where ice formed on the wings due to the cold weather conditions. No de-icing was requested the following morning by the pilots before the flight with three passengers to Bangor airport in Maine. Ice on the wings caused one wing to dip on take-off and the aircraft inverted and crashed into grass beside the runway and caught fire. There were no survivors.

A TNT Airways cargo Boeing B737-301F (OO-TND) with damaged landing gear made an emergency landing at Birmingham on 15 June 2006. The aircraft had been flying from Liège in Belgium to Stansted, but was diverted to East Midlands Airport because of poor visibility. The pilot momentarily disengaged the autopilot approach, causing the aircraft to deviate from the course, and it hit the grass to the side of the runway, which caused the right main gear to detach. Damage was caused to the right inboard flap, wing/body fairing, and rear freight hold door, and resulting in the loss of a hydraulic system. The crew initiated a go-around, declared an emergency, and diverted to Birmingham. The aircraft landed and came to rest on the runway supported by the left main landing gear and right engine. Human error was attributed to the incident and both pilots were subsequently dismissed.

A Cessna 501 Citation ISP (G-VUEM) on a Commercial Air Transport flight was bringing a human liver from Belfast airport on 19 November 2010 for a transplant operation (which was subsequently completed successfully) when it crashed after hitting the glideslope antenna at Birmingham Airport during final approach in thick fog. Coming to rest in an upright position, a fire broke out and the Airport Rescue and Fire

Fighting Service had some difficulties locating it. Both crew members were injured, one seriously, and the aircraft was damaged beyond repair. The airport reopened at around mid-day the following day.

A Lithuanian Air Aurela Boeing 737-35B (LY-SKA) leased to Monarch Airlines skidded off the runway after it touched down in heavy rain at Birmingham Airport from Nice, France, on 21 September 2012. Its wheels overshot the runway and got stuck in a grass verge alongside the tarmac, causing a two-hour closure while heavy lifting gear eventually towed the stricken aircraft away. There were no injuries among the 143 passengers or the crew.

A Small Planet Airlines Airbus A320-233 (SP-HAI) ran off the taxiway and stopped on the grass after landing at Birmingham airport after its flight from Paderborn, Germany, on 21 February 2016. All ninety-eight passengers safely disembarked the aircraft with no injuries to them or to the flight crew.